MAKING AMERICAN ARTISTS

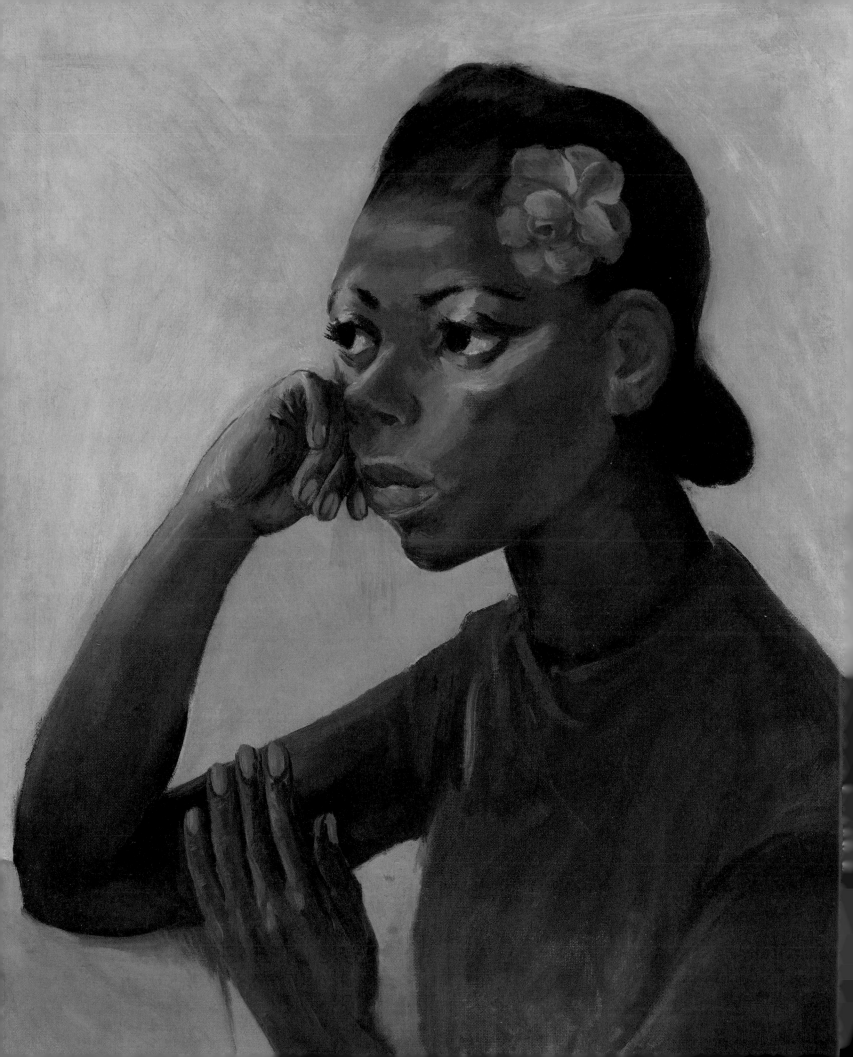

MAKING AMERICAN ARTISTS

STORIES FROM THE PENNSYLVANIA
ACADEMY OF THE FINE ARTS
1776–1976

EDITED BY ANNA O. MARLEY

WITH CONTRIBUTIONS BY MICHÈLE WIJE, DANA E. BYRD,
CHRISTIAN AYNE CROUCH, AND JONATHAN D. KATZ

AMERICAN
FEDERATION
OF ARTS

HIRMER

DIRECTOR'S FOREWORD

PAULINE FORLENZA
DIRECTOR AND CEO
AMERICAN FEDERATION OF ARTS

The American Federation of Arts (AFA) is thrilled to present *Making American Artists: Stories from the Pennsylvania Academy of the Fine Arts, 1776–1976*. It seems apt that this exhibition and the accompanying catalogue have resulted from a collaboration between two storied American cultural institutions: the AFA and the Pennsylvania Academy of the Fine Arts (PAFA). Inaugurated in 1805, PAFA was the first museum and art academy established in the United States, while the AFA, founded in 1909, was the first organization to travel exhibitions nationally. Though based in different cities, the objectives of both institutions have always been aligned in their desire to advance the cause of art and to cultivate artists in the United States.

When AFA and PAFA leadership met to discuss what form a traveling exhibition of historical and modern art from PAFA might take, there was a shared recognition of the importance of presenting this esteemed collection of American art in a manner that emphasizes PAFA's long-standing commitment to access and inclusion.

Making American Artists thus presents over one hundred works that together surface narratives about women artists, LGBTQ+ artists, and artists of color who have shaped the nation's history and visual identity. By looking at American art through two hundred years of creativity and change, and juxtaposing well-known historic works alongside stellar pieces by traditionally underrepresented artists, both the exhibition and publication probe what it means to be an American artist.

This exhibition and catalogue exist as the result of tireless contributions by several individuals. I would like to thank Eric Pryor, President and CEO of PAFA, for supporting this collaboration. Anna O. Marley, Chief of Curatorial Affairs and Kenneth R. Woodcock Curator of Historical American Art at PAFA, brought to life this comprehensive exhibition and worked with the AFA to organize it alongside her own committed team, including Danielle McAdams and Adrian Cubillas, who arranged the logistics for the show and photographed the collection for the catalogue respectively.

This project could not happen without the dedication of our institutional colleagues, and I am grateful to the museums and venues who have recognized the importance of this exhibition. The show will travel to wonderful partners including the Wichita Art Museum, Kansas; the Albuquerque Museum of Art, New Mexico; the Philbrook Museum of Art, Tulsa, Oklahoma; and the Ackland Art Museum at The University of North Carolina at Chapel Hill.

This sumptuously illustrated catalogue authored by respected scholars offers an innovative and critical examination of PAFA's collection. Special thanks to scholarly editor Anna O. Marley for convening a superb roster of contributors, including Dana E. Byrd, Jonathan D. Katz, and Christian Ayne Crouch, who effectively interrogate and expand upon existing knowledge about the collection, offering reinterpretations of American works of art. I would also like to thank Elisabeth Rochau-Shalem and Rainer Arnold of Hirmer Publishers for their partnership in co-publishing this book, as well as talented designer Sabine Frohmader and careful copy editor David Sánchez Cano.

Thanks are due to my former and present AFA colleagues, including to Andrew Eschelbacher for spearheading this project, as well as to Michèle Wije and Katharine J. Wright for shepherding the organizational aspects of the exhibition and being the liaisons for PAFA and the host venues. Orian Neumann and Anne Reilly managed the project and made all the logistical arrangements. Nicholas Cohn, Sarah Fonseca, and Kristin N. Sarli were responsible for all the excellent development, communications, and event planning related to the show. Thank you to Anna Barnet for her thoughtful work on all aspects of this publication.

As the United States approaches its 250th anniversary in 2026, the AFA is delighted to have partnered with PAFA to create a historic exhibition that looks forward to the future while exploring the diverse and complex events of the country's past.

PRESIDENT'S FOREWORD

ERIC PRYOR
PRESIDENT AND CEO
PENNSYLVANIA ACADEMY OF THE FINE ARTS

We at PAFA are thrilled to share with audiences around the country the most iconic works from our collection, alongside pieces by traditionally underrepresented artists, to pose questions about what it meant to be an American artist when the institution was founded and what it meant to be an American artist by the late twentieth century. PAFA is the nation's first art museum and art school. Founded in 1805, PAFA has been collecting contemporary art from its inception. Our collection comprises more than 16,000 works and over a quarter of it is work by artists of color and women artists. PAFA exhibits the permanent collection by integrating artwork throughout the galleries, juxtaposing contributions by artists from historic, twentieth century, and contemporary periods. By exhibiting work in this way, we aim to create a meaningful dialogue between visitors and artwork.

Making American Artists: Stories from the Pennsylvania Academy of the Fine Arts, 1776–1976 presents over one hundred of the most acclaimed and recognizable works of American art, which have played a demonstrable role in shaping conversations about the nation's history and identity. The exhibition offers new narratives of the history of American art, embracing stories about women artists, LGBTQ+ artists, and artists of color within a visual and thematic structure that also features works traditionally associated with the Pennsylvania Academy of the Fine Arts. When Charles Willson Peale founded PAFA with the sculptor William Rush in 1805, they created an institution that was devoted to groundbreaking initiatives in championing American art and artists—what that looks like has changed demonstrably throughout the last 217 years. This exhibition explores PAFA's impressive collection with a critical eye and emphasizes its transformative contribution to the history of American Art.

We hope this small sampling of works from our collection inspires you to visit us at our impressive galleries in Center City, Philadelphia. Our National Historic Landmark Building was completed in 1876 by Frank Furness and George Hewitt and is where our permanent collection is primarily exhibited in just under 20,000 square feet of exhibition space. The building is often described as a factory for the making and displaying of contemporary American art and is one of the most architecturally influential museum buildings in the country, merging flamboyant Gothic elements with cutting edge industrial-era aesthetics. Our Hamilton Building was acquired by PAFA in the early 2000s and its opening was celebrated in 2005 for PAFA's 200th anniversary. Constructed in 1916, the building was originally the home of the Hudson Motor Company, which worked to our benefit as its foundations are strong enough to include a foundry on the seventh floor. The Hamilton Building has 24,569 square feet of exhibition space.

We look forward to welcoming you to Philadelphia in 2026 as we celebrate the 250th birthday of the United States and continue to celebrate and define what makes American art and American artists.

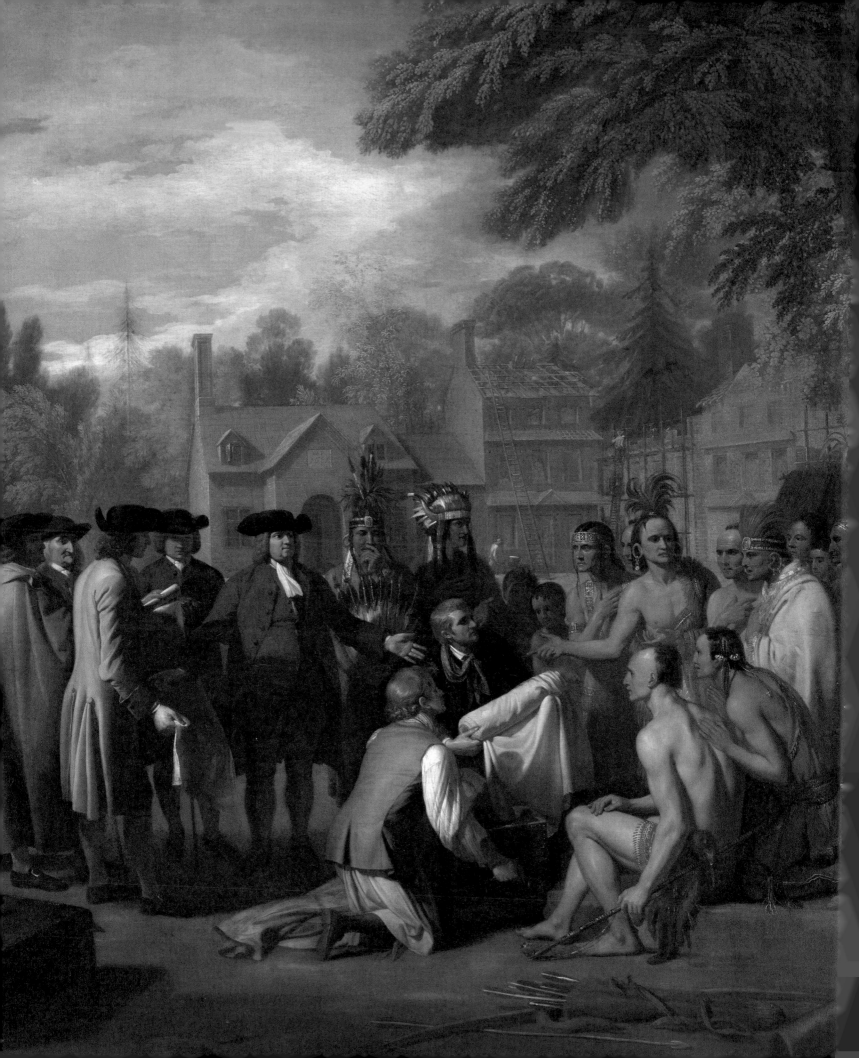

PRETTY PICTURES AND THE (RE)FRAMING OF AMERICA

CHRISTIAN AYNE CROUCH

What is an American? This query, which is taken up by Salish/Kootenai contemporary artist Jaune Quick-to-See Smith in her print of the same title, cuts to the heart of the contested histories of the United States and is an excellent reminder of the importance of visual narratives in these questions (2001–3, fig. 1). The print *What Is an American?*, like much of Smith's work, engages the centrality of Native dispossession in the making of the United States and simultaneously challenges who has the authority to define "American" and "American artist." Her appeal for viewers to rethink what has been normalized and defined as familiar fits well with the theme of this exhibition, which follows the making of American artists.

From its founding in 1805 as the United States's first museum and fine arts school, the Pennsylvania Academy of the Fine Arts (PAFA) has been at the center of both the training of American artists and the curation of what constitutes "American" representation. Remember though, that the word "America" emerged as a term of imagination, first used by a German mapmaker to label the rough outline of the Florida peninsula in honor of Amerigo Vespucci. America competes with Indigenous nomenclatures, such

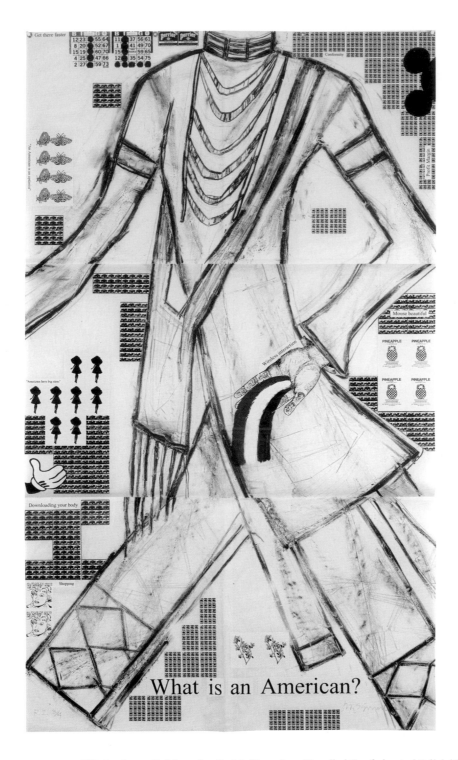

FIG. 1.　Jaune Quick-to-See Smith (American/Enrolled Confederated Salish/Kootenai Nation, b. 1960), *What Is an American?*, 2001–3. Lithograph, chine collé, monotype, ed. ¾, 68 × 40 in. Pennsylvania Academy of the Fine Arts, Gift of Ofelia Garcia, 2015.42.11.

as Tsenacommacah, Lenapehoking, Ndakinna, or Turtle Island, that reflect the continued presence of Indigenous peoples in their homelands. The process of defining and policing the boundaries of what constituted America, and American, accelerated in the eighteenth-century Atlantic world as not only a political project but also a deeply cultural one, the contours of which are the subject of *Making American Artists*.

The works of art at PAFA are in dialogue by their presence within the institution's collection; many share elements Americans consider essential to the nation's identity, while at the same time not representing anything universal to the American experience. This paradox is itself a key to the American identity as we live it day by day. Benjamin West's *Penn's Treaty with the Indians* (pl. 36) was not a founding acquisition of PAFA, but his painting has come to stand in as a shorthand point of origin for both American art and American artists. Born in 1738 in the Pennsylvania colony, West's fame arose from his talent and novelty as the first accomplished "American" artist, transforming his colonial roots through European fine arts training into a star career as a painter to King George III. West broke rules in traditional history painting, the pinnacle of European painting genres, by representing "American" happenings (instead of European history or antiquity) and by depicting events in contemporary, rather than classical dress, as in 1770's *The Death of General Wolfe* (National Gallery of Canada) and 1771–72's *Penn's Treaty with the Indians*. In 1878 this latter work came to PAFA as a donation from the carefully composed collection of American art amassed by Sarah and Joseph Harrison, Jr., enshrining PAFA's mission as the premier arts institution in the United States. West's canvas purported to represent the founding of the "peaceable kingdom" colony of Pennsylvania, a settlement allegedly founded on negotiations between Lenape peoples and a recent arrival in their homelands, colonist William Penn.

Shown at PAFA, West's work offered Philadelphia a renewed way to assert its supremacy as a cultural and moral capital in the United States. The painter was American-born, (conveniently overlooking West's loyalism and extended career in Britain), and claimed for Pennsylvania, and PAFA, an established arts education tradition. West's representation, a forerunner to painter Edward Hicks's 1833 folk art *The Peaceable Kingdom* (pl. 40), put forth Pennsylvania as a distinguished, and superior, contrast to Virginia's and Massachusetts's bloodstained pasts. For visitors seeing West's canvas at PAFA after the Civil War and the 1876 Philadelphia Centennial Exposition, and amidst the ongoing violence of the Plains Wars, *Penn's Treaty with the Indians* assuaged mainstream Euro-American audiences. It portrayed the colonial roots of the United States as just and harmonious, smoothing over the mess of empire and conquest taking place in their contemporary lives and instead allowing retreat into the euphemistically-termed "westward expansion" and imagined tranquil progress.

From its inception, West's work invented American pasts, and he invented himself as "the" American artist. West produced a history painting but he was not, in fact,

painting history. Careful study of the composition reveals West's indebtedness to multiple tapestry cartoons by Raphael Sanzio (1483–1520), which he would have had access to in the collections of his patron, George III. His image reveals much about the Penn family aspirations and West's own ambitions as an artist, but little about what actually took place in and after 1682. Beyond Renaissance templates, West blended Native material culture from his own era with older European tropes of representing imagined Indians to realize this particular work. William Penn's son, Thomas Penn, and Benjamin West did, in their lifetimes, have to reckon with the reality that colonial America was a heterogenous place that sat at the intersection of Native homelands and colonial outposts. Painting in 1771, West attempted to render his patron's colonial aspirations as inevitable reality, naturalizing the progression of Indigenous displacement. The Lenape individuals portrayed as engaging in negotiations and a treaty with Penn in 1682 do so against a backdrop that falsely imposed Anglo-Dutch architecture in Lenapehoking at the moment of colonial invasion. West projected fictions in equal measure, both in regards to the nature of Indigenous encounters and in the rendering of overwhelming European colonial expansion. Alteration of the landscape formed one among many tools in the arsenal of settler colonialism; *Penn's Treaty with the Indians* accelerated the visualization of a process that was nowhere complete or certain in 1771.

Thomas Penn commissioned West to celebrate the distant, rather than recent, past, preferring to commemorate his father William's interactions with Native peoples, minimizing his own fraught relationship with the Lenape and his break with the Society of Friends. Decades earlier, Thomas Penn, his brother, and the Pennsylvania provincial secretary had purported to recover a 1686 deed and alleged this textual artifact had given Lenape approval for William Penn to acquire the land within a thirty-six hour walk of the colonial settlement of Wrightstown. This deed and interpretation put into motion a process known euphemistically to Euro-Americans as "the Walking Purchase." The Penns turned to the colony's fastest distance runners, whose sixty-mile "walk" became the baseline for claiming one *million* square miles of Lenape homelands. The Lenape leader, Lappawinsoe, voiced his frustrations in 1737 at what the community came to call the "Running Walk," a fraudulent premise which accelerated a process of dispossession that continued for the community into the nineteenth century, relocating Lenapes to current-day Oklahoma, Wisconsin, and Ontario. West's 1771 vision of an idealized past of 1682 effectively erased the reality of the more recent, and far more violent, dispossession undertaken by Thomas Penn and offered a visual idiom for "American artists" to commodify in their pursuit of position and voice in the new United States—a visual strategy supported by American artists and which continued and accelerated the tragedy of Native removal for hundreds of years.

Even before *Penn's Treaty with the Indians* came to PAFA, West's work was widely admired in the Atlantic world and reproduced in prints, setting a model for a certain set of American artists to generate their national bona fides by selecting from among

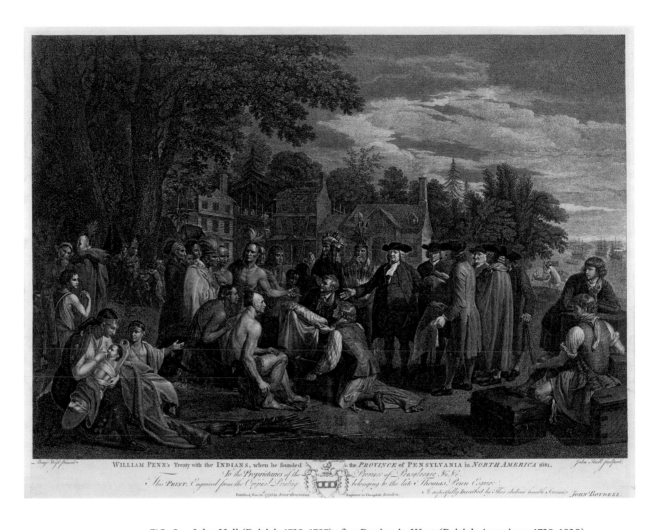

FIG. 2. John Hall (British, 1739–1797) after Benjamin West (British American, 1738–1820), *William Penn's Treaty with the Indians*, 1775. Engraving, etching, and stipple on cream laid paper, 16 ¾ × 23 ¼ in. Pennsylvania Academy of the Fine Arts, John S. Phillips Collection, 1985.x.718a.

three genres: first, the depiction of American history painting (the style put forward by West and continued by individuals like John Vanderlyn in his 1805 *The Death of Jane McRae* or John Gadsby Chapman's 1840 *The Baptism of Pocahontas,* or Emanuel Gottlieb Leutze's 1851 *Washington Crossing the Delaware*). Second, West's historical rendering visually emphasizes the genre of what Ojibwe scholar Jean M. O'Brien has referred to as the "firsting and lasting" of Native peoples.[1] In the arts, this could run from the ethnographic portraits of Native individuals by George Catlin or Elbridge Ayer Burbank to Edward Curtis's photographs of those he deemed to be vanishing peoples. Generations of American artists sought to "make it" by satisfying the visual imperatives of the new nation, affirming Native peoples as only being "authentic" if located in the past and continuing aesthetic, linguistic, or cultural practices that remained unchanged and, therefore, destined for extinction in a modern world. Third, although West served the British empire rather than the new US republic, his authority as both

an artist and academician ensured limitations on who would be allowed to produce arts, or instruct artists.

West's painting has been made iconic and continues to be erroneously used as a painting of history, rather than being correctly read as an allegorical history painting. Its power ultimately emerged not just in the limitation of who could be American artists by depicting American topics, but also for its influence in what has come to be the most common elements of US visual culture: consumer and popular art. Print culture, from the eighteenth-century forwards, allowed individuals an affordable way to participate first in British imperial and then in US republican cultural development through the acquisition of engraved copies of famous portraits and paintings. West's images, through replica, mass-produced plates, circulated widely and accordingly expanded the reach and ubiquity of his faux visual history (fig. 2). Audiences who have never seen PAFA's canvas in person may have encountered it, or an engraved copy, as an illustration in schoolbooks or in cannibalized elements which make the work, when finally seen, familiar. That familiarity reinforces viewers' inclination to take West's representation as history rather than the creation of mythology. American popular culture has rendered his figures iconic, through logos of the Quaker Oats company, the stoic Indian leader, or allegories of the United States as a Native "maiden."

If we look beyond *Penn's Treaty with the Indians* and the evolution of the American artists showcased at PAFA, we see how some American artists and makers have turned towards, or against, history painting (in the classic sense of the term) to challenge both the genre and the restrictions on who, or what, can be seen as American. Whether in the service of being able to break into the mainstream or in the desire to inscribe and preserve narratives actively marginalized by the United States and the mainstream population in power, American artists have turned time and again to visual representations as a counter-archive. This project features artists, including Henry Ossawa Tanner (pl. 18) or Horace Pippin (pl. 51), who rejected a tidal wave of visual stereotypes circulating in every form from high art through cartoons and ephemera in the Global North. Reclaiming sculpture and history painting, they demonstrate and make apparent, through their own community-based approaches, the contrast with the dominant constructed nature of history in the Euro-American history painting tradition on full display in *Penn's Treaty with the Indians*.

James Baldwin's reflection in relationship to the African American experience that "The history of America is the history of the Negro in America. And it's not a pretty story,"[2] merits our attention in relationship to art and visual culture. Note, for instance, the absence of people of African descent in West's painting, which belies the reality of the British Atlantic empire, including Pennsylvania. Baldwin's criticism cuts to the heart of the matter, the very question of the making of American artists and the contested terrain of the American past that continues to be made and remade. Ending *Making American Artists* at the 1976 bicentennial demonstrates the progress beyond

West. The stakes of being both an American artist and engaging in history painting remain current and potent. By the turn of the twentieth century, PAFA was providing space for men and women of African descent, such as May Howard Jackson (pl. 47), to insert themselves into conversations about American arts. Today, the museum is reconsidering the mission of its collection in regard to the overlooked Indigenous "American artists" who might dispute the very use of the term "American."

Making American Artists's temporal frame of 1776 to 1976 encompasses the first two centuries of the United States and encapsulates omissions dating to the arrival of West's work at PAFA in 1878. US cultural institutions sharply delineated between "art," housed at museums like PAFA or New York's Metropolitan Museum of Art, founded in 1870, and "natural history," updated cabinets of curiosities featuring everything from dinosaurs to non-European peoples, such as the American Museum of Natural History, founded in 1869. As a result, for years PAFA, like most of its peers, acquired few or no works by Native artists because these were not considered fine art. In the 1980s, PAFA catalogued a collection of Plains Native ledger art from a century earlier, yet this act of inclusion continued the mainstream American paradigm of focusing on "authentic" collections of Indigenous arts and crafts, while explicitly or implicitly maintaining stereotypes of Indigenous peoples as located in the US past and reserving to Euro-American experts the right to define "real" Indigeneity. The self-limitations of this project are corrected by looking at an 1879 image made by an Arikara man named Ahuka, *Peacemaking between the Arikara and the Sioux*, in PAFA's collection (fig. 3). It is a history drawing that reveals the essential place of Native America to any rendering of continental history, perhaps more than any other work in PAFA's collection. Ahuka's experience was made by Native worlds, US expansion, and Indigenous resistance to this—a different and valuable genealogy for making American artists. This two-dimensional plane overcomes the mythmaking project of West and Penn, and the US visual historical project, by presenting an alternative, accurate rendering of who is American and what was happening in American history at that time. The horse culture in Ahuka's image depicts Indigenous adaptation to a changing world, not just for mere survival, but recognizing and celebrating the full complexity of their experience of progress.

In 2015, PAFA received the work of a contemporary and living Indigenous artist, Jaune Quick-to-See Smith's 2001–3 print *What Is an American?*, and put her work on display a year later, as a belated but important recognition of the institution's representational needs. It took another five years for the National Gallery of Art to make a highly publicized purchase of a work by any living Native artist for the first time in its history (Jaune Quick-to-See Smith's 1990 painting *I See Red: Target*). Curators, staff, leadership, and visitors at art institutions are engaging a fuller consideration of history painting and the making of American artists, but the omission of Indigenous artists as central in this dialogue shows how much work remains to be done. Smith's *What Is an*

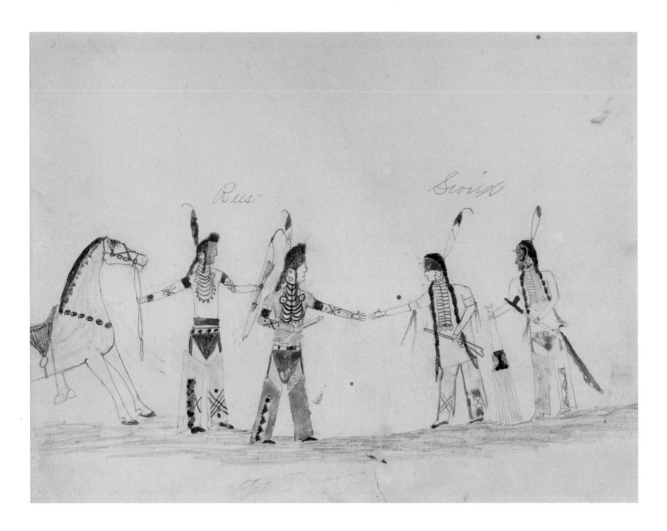

FIG. 3. Ahuka (Arikara, 1858–1884), *Peacemaking between the Arikara and the Sioux*, 1879.
Pencil and watercolor on cream tagboard, 8¾ × 11 in.
Pennsylvania Academy of the Fine Arts, 1982.x.151.

American? explicitly takes on the tropes of US popular culture that export a vague idea of "America" rooted in corporate logos, consumer culture, and popular media to a global market that West could only have dreamed of. If, at PAFA, the consideration of making American artists begins with West and runs through Smith, then we confront the irony that while West offered deeply flawed and self-serving portrayals of Indigenous individuals, he had to recognize their centrality to America. Neither he, in his time, nor contemporary viewers today, can accept an omission of Indigenous makers, artists, and activists from the discussion of American art. West's value is not in representing an accurate history—the time now is for the Indigenous works at PAFA to lead the way in helping institutions to think expansively about the making of America and the making of American art, and to correct the broken promises, erasures, and mythologies of the US arts narrative. West's painting is the eighteenth-century benchmark of a certain ideal of pacific progress. The Arikara history drawing is, in a totally different

yet quintessentially American context, and a century later, the depiction of a similar ideal of pacific progress. But then Smith's print speaks its truth. What considerations of culture and trade, commerce and the right to land use are to govern this land now commonly called America? Who can access this ideal of peaceful progress? Who in our own day is to be considered an American? Her answer in this work is a partial figure, whose features remain out of sight.

1 Jean M. O'Brien, *Firsting and Lasting: Writing Indians Out of Existence in New England* (Minneapolis: University of Minnesota Press, 2010).

2 James Baldwin, *I Am Not Your Negro: Major Motion Picture Directed by Raoul Peck with Texts from James Baldwin,* compiled and edited by Raoul Peck (New York: Vintage, 2017), 95.

STORIES FROM THE PENNSYLVANIA ACADEMY OF THE FINE ARTS

ANNA O. MARLEY AND MICHÈLE WIJE

In 1894, nearly a century after the founding of the Pennsylvania Academy of the Fine Arts (PAFA), Charles McIlvaine, writing for the art journal *The Quarterly Illustrator,* lauded the institution:

> There is a veritable savor of 1776 about the Pennsylvania Academy of Fine Arts. . . . Of those who fathered a nation were the parents of the first American Art Academy. In their far-reaching thoughtfulness they did not forget that the success of the people depends upon its enlightenment; that each enlightenment is an art and that the greatest of this is Art.[1]

The lavishly illustrated article was written during the tenure of Harrison S. Morris, who had been appointed Secretary and Managing Director of the Academy in 1892, and who was the nation's first professional arts administrator. Morris, portrayed by Thomas Eakins in 1896 (pl. 19), invigorated PAFA in the late nineteenth century and is credited with presiding over a period of enlightened collecting and exhibitions.

McIlvaine goes on to predict that PAFA's artistic heritage as "the oldest American Art Academy" would project "a future for American Art which shall give it first place among the nations of the earth."[2] Over 125 years later and just shy of the nation's 250th anniversary, it seems fitting to reexamine this expectation with fresh scrutiny.

Making American Artists: Stories from the Pennsylvania Academy of the Fine Arts, 1776–1976 allows for a reconsideration of PAFA's storied legacy and unparalleled collection by viewing it through the lens of America's collective history. It acknowledges the proliferation of voices that have given the American nation its distinct character, rather than focusing on a univocal, monolithic narrative. In recent decades, the center of gravity for social and historical debate about identity and what it means to be an American has altered, both in the national discourse and in the study of American art. A re-interpretation of PAFA's collection allows for a visual accounting of shifting narratives and perspectives. PAFA's museum collection includes many of the most important works created by American artists and its Academy has educated many of the country's most celebrated artists, as well as several who have not yet received their critical due. The depth and breadth of PAFA's collection is therefore an excellent point of departure to investigate questions about who constructs history and how its reception can be articulated. Historians of American art have long placed issues of identity under the magnifying glass. However, the topic seems particularly relevant now when our collective social awareness includes analyzing historical and present-day attitudes toward identity in terms of race, ethnicity, sexuality, and gender.[3] Re-interpreting a well-known collection of American art while acknowledging its venerable traditions now requires an alternative organizing principle outside of the canonical modes of observation. In his foundational, yet almost twenty-year-old state-of-the-field article on American art, John Davis wrote that scholars are "engaging in a much broader critique of the categories and institutions of American art, as well as the patriarchal assumptions that constructed them."[4] *Making American Artists* adheres to this approach by exploring PAFA's dual legacy of training artists and collecting the art of the United States, bringing new perspectives and scholarship to bear on over 100 iconic American paintings and sculptures made from 1771 to 1977 and their continuing role in telling the story of twenty-first century America. While PAFA is well known and lauded for its work collecting women artists and Black artists, it has much work to do in expanding its collection of Asian American, Latinx, and Native American artists outside of the contemporary arena.[5] This lacuna can clearly be seen in the collection of works presented here from 1776 to 1976.

PAFA is the oldest art museum and art school in America. It was founded in 1805 in Philadelphia, which up until 1800 had been the nation's capital and its leading cultural and intellectual center. The artist and scientist Charles Willson Peale (pl. 8), the sculptor William Rush (pl. 38), and other civic-minded artists and business leaders shaped a teaching and collecting institution that quickly assumed national importance. They

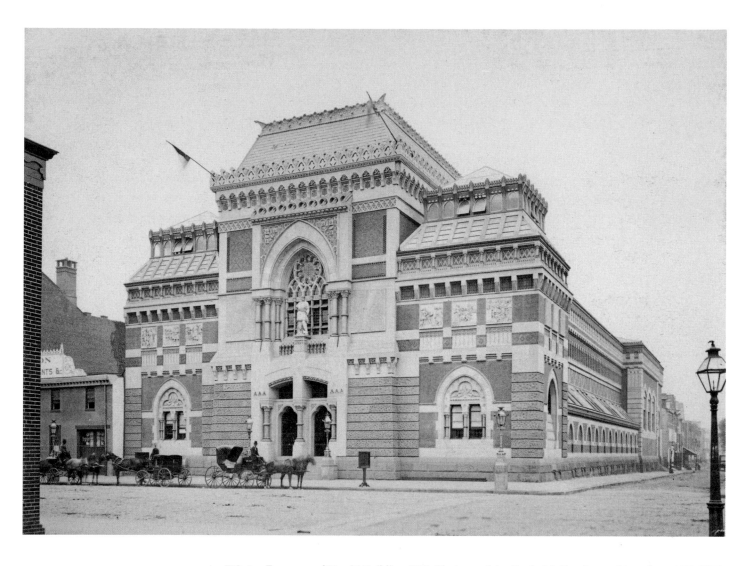

FIG. 1. Furness and Hewitt Building, 1876. Photograph by Frederick Gutekunst (American, 1831–1917). Stereograph, 4⅜ × 6 in. The Pennsylvania Academy of the Fine Arts' Archives, Philadelphia. Building photograph collection, PC.01.03.

modeled their project on the Royal Academy in London and the New York Academy of Fine Arts that had been established in 1802. They made the expatriate American painter Benjamin West (pl. 36), then president of the Royal Academy and historical painter to England's George III, PAFA's first honorary member. West strongly believed that "the youth of America have talents for the fine arts," and his generosity and assistance to young American painters such as Gilbert Stuart (pl. 4) and Thomas Sully (pl. 10) helped establish their careers.[6] The Board of PAFA supported the efforts of American artists from the outset. When PAFA staged its first exhibition in 1807, it combined plaster casts, paintings by West and Peale, and works by contemporary British artists. By 1811, the inauguration of annual group exhibitions allowed American artists, including women artists, to display their work, with the Board clearly stating,

"Paintings by American and living artists shall always have a preference over those by European or Antient [sic] artists."[7]

From the 1820s through 1850 local Schuylkill River and later Hudson River School landscape paintings by Thomas Birch (pl. 81) and Thomas Doughty (pl. 82) were popular in the annual exhibitions, along with large-scale theatrical history paintings by PAFA President Peter Frederick Rothermel (pl. 42) and neoclassical marbles made by American artists working in Rome including Hiram Powers (pl. 41) and Harriet Hosmer (pl. 11). By 1850, and certainly following the Civil War, American society underwent significant changes. While PAFA was never a place just for White, male artists, women students

FIG. 2. A women's art class at the Pennsylvania Academy of the Fine Arts, c. 1880s. Photographic print, 7½ x 9⁵⁄₁₆ in. The Pennsylvania Academy of the Fine Arts' Archives, Philadelphia. School classes photograph collection, PC.01.10.

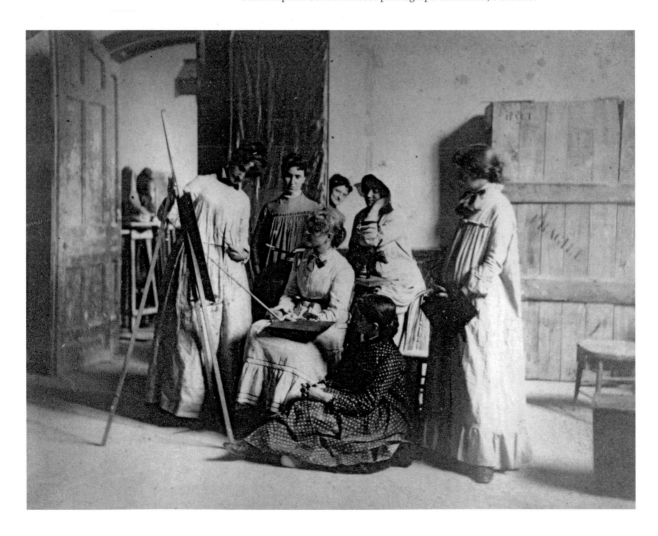

had been subject to the constrained moral standards of the day and were restricted to copying antique casts of male nude statuary, and had no access to study of the live nude model. By 1856, however, they were no longer separated in women's classes when the Board decreed that "a close fitting, but inconspicuous fig leaf" be attached to the sculptures. Similarly, PAFA did not shy away from dealing with situations surrounding race and inequality. In 1857, the board agreed with a request by the Reverend William H. Furness that "decent and respectable colored persons" be admitted to Academy shows "upon the same terms as decent and respectable white persons."[8] In the 1860s, PAFA sold its first buildings on Chestnut Street and the decision about its next location caused a rift on the board. The Civil War caused disruptions to the schedule of special exhibitions, but the school attracted many students who would go on to be some of the most influential American artists, including Thomas Eakins (pl. 16), Mary Cassatt (pls. 44, 69), and Emily Sartain (pl. 13).

Between 1876 and 1905, PAFA enjoyed a sustained period of success and stability. The opening of the new building designed by Frank Furness and George Hewitt (fig. 1) coincided with the celebration of the nation's centennial. In subsequent decades important donations helped augment the permanent collection, while the Joseph. E. Temple Fund and Henry D. Gilpin estate established funds for acquisitions. In 1878, Philadelphian financier and mechanical engineer Joseph Harrison, Jr., who had made a fortune building locomotive engines for Czar Nicholas I in Russia, gave his collection to PAFA. Among the seventeen works were Peale's *The Artist in His Museum* (1822, pl. 8), West's *Penn's Treaty with the Indians* (1771–72, pl. 36), and John Vanderlyn's *Ariadne Asleep on the Island of Naxos* (1809–14, pl. 37), believed to be the first female nude painted by an American artist. Thomas Eakins was a notable presence in the 1880s as an artist and instructor. He was instrumental in innovating teaching practices at PAFA by putting emphasis on the study of human anatomy, including the dissections of animals and human cadavers and reducing the traditional reliance on the study of antique casts. He introduced a sculpture class that modeled the body from life. In 1886, Eakins was dismissed from the faculty ostensibly for his use of nude models of both genders in male and female classes (fig. 2), for lifting a loin cloth from a male model in a female life class, and for using students as nude models.[9]

Cecilia Beaux (pl. 15), one of America's most significant female artists and proclaimed by PAFA fellow professor William Merritt Chase (pl. 17) as "the greatest woman painter of modern times," also taught at the school.[10] Harrison S. Morris, who stated "there is . . . a kind of halo about her and her work . . . she was so rarely talented," championed her work, purchasing one of her paintings in 1896.[11] This acquisition made Beaux not only the first full-time woman professor of painting at PAFA, but the first woman to have her work purchased for the collection. Morris led the way at PAFA with groundbreaking displays of photographic art. He was also responsible for the acquisition of Winslow Homer's *Fox Hunt* (1893, pl. 87), the first work by the artist to enter a public

collection, and Henry Ossawa Tanner's *Nicodemus* (1899, pl. 46), the first work by an African American artist to enter PAFA's collection. Significantly, in 1895 May Howard became the first African American woman to receive a scholarship to attend PAFA (see pl. 47). Historically, the institution was known to purchase work directly from artists' studios, a daring decision at the time. It showed a commitment to promising and underrecognized artists. Homer's *Fox Hunt* and Edward Hopper's *Apartment Houses* (1923, pl. 76) were both acquired in this way.

In the twentieth century, PAFA was not as nimble in responding to new art movements as it had been for much of the long nineteenth century. Its endorsement of impressionism prevailed, while its institutional commitment to modernism was inconsistent, although it fostered the careers of modernists Arthur B. Carles (pl. 24), Robert Henri (pl. 26), and Marianna Sloan (pl. 93). Two world wars tempered social enthusiasm for art in general and hampered the institution's ability to train artists and exhibit their work. Nevertheless, in 1921, a bold exhibition of modern art titled *Exhibition of Paintings and Drawings Showing the Later Tendencies in Art* opened at the Academy and was limited to American artists. Works by William J. Glackens, Arthur Garfield Dove, Charles Sheeler, and Georgia O'Keeffe marked the first exhibition of modernist works by Americans in an American museum. Notable and important acquisitions in the first half of the twentieth century include Horace Pippin's *John Brown Going to His Hanging* (1941, pl. 51) and Andrew Wyeth's *Young America* (1950, pl. 80). These works, among others, demonstrate PAFA's leadership role in supporting living artists who offered nuanced critiques of US history and identity. In general, however, the tenor of the institution in the mid-twentieth century was conservative. By mid-century, when abstract expressionism dominated American artistic circles, PAFA rarely added abstract works to its collection, with notable exceptions such as Stuart Davis's *Ultra-Marine* (1943, pl. 101), Janet Sobel's *Invasion Day* (1944, pl. 52) and Isamu Noguchi's *Girl Torso* (1958, pl. 32). Frank H. Goodyear Jr., PAFA's first modern curator, would later describe the institution as a "slumbering giant" that provided "continuity but little growth." For the remainder of the twentieth century, PAFA bolstered its collection with works that addressed lacunae in the collection, including works by Dove (pl. 97), Laura Wheeler Waring (pl. 29), Sonja Sekula (pl. 102), and Julius T. Bloch (pl. 31).

Though often thought of as conservative, PAFA was a generative space for the socio-political liberalism and civil rights debates that marked the 1960s and '70s in America. The Black artist Barkley L. Hendricks was accepted at PAFA in the fall of 1963, entering the institution during this period of intense social change and racial anxiety. Raymond Saunders, an earlier Black graduate of the Academy, had challenged some of the philosophical ideals of the school, most notably in his 1967 self-published pamphlet *Black Is a Color*. Hendricks began his training along with another Black student, James Brantley, the subject of his painting *J. S. B. III* (1968, pl. 34), in the wake of these racial debates. At PAFA he was introduced to drawing from the nude model and the

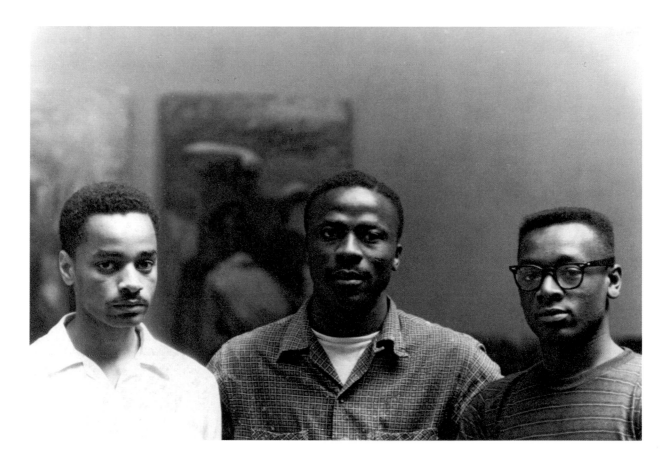

FIG. 3. Louis Sloan (Schiedt Winner), Francis Acquaye (Cresson and Ware 1958 Winner), Raymond Saunders (Cresson, Eakins, and Grant Winner) at the Pennsylvania Academy of the Fine Arts' Cresson Day, 1956. Photographic print, 8 × 10 in. The Pennsylvania Academy of the Fine Arts' Archives, Philadelphia. Cresson Awards photograph collection, PC.01.14.

traditions of painting that emphasized color and figuration. While Raymond Saunders was a recipient of the prestigious William Emlen Cresson Memorial Traveling Scholarship in 1956 (fig. 3), Hendricks was the first Black artist to be awarded two consecutive travel grants, the Cresson and the J. Henry Scheidt Traveling Scholarship. These grants enabled him to travel through Western Europe and North Africa. PAFA entered this radical time in America by providing a structure and space for, in particular, women artists such as Elizabeth Osborne (pl. 33) and Black artists, including Brantley, to thrive in a fine art setting where they could merge abstraction and figuration in their painting practice. In the 1960s, Philadelphia was a nexus for jazz and art, and the city became a formative influence for many artists. In 1967, David Lynch, then an advanced painting student at PAFA, was already creating work that brought together painting, sculpture, sound, film, and installation before he went on to become an internationally renowned filmmaker. In the 1970s, just as it was in the 1770s, Philadelphia was a center of radicalism, as a nexus of the Black arts movement and the home of FOCUS: Philadelphia Focuses on Women in the Visual Arts, a city-wide arts program that took place in April

and May of 1974, one of the first feminist art shows in the nation. That radicalism of both art and politics is embodied in the comparison of PAFA founder Peale's portrait *George Washington at Princeton* (1779, Princeton University Art Museum)—depicting the first US president, who enslaved Black Americans—and James Brantley's *Brother James* (1968, pl. 35)—depicting a Vietnam veteran, a self-portrait of a Black artist. In these paintings, two American veterans pose for their portraits and embody very different aspects of American masculinity, race, and leadership. The exhibition that accompanies this catalogue is built around such juxtapositions, and it is the works of art themselves that ask the most compelling questions about American history, identity, and the role of the artist in defining these.

Today, as McIlvaine predicted, as the first art school and museum in the country, PAFA continues innovating for the future of American art with living artists. As a result, its well-recognized strengths can present an expanded view of the artists, faculty, and individuals who have shaped the development of American art. Important historic portraits, such as *Profile Portrait of George Washington* (c. 1784–6, pl. 2), attributed to Patience Lovell Wright, or Peale's *George Washington at Princeton* that convey stories about revolutionary era politics can be shown alongside works such as Brantley's *Brother James* or Hendricks's *J. S. B. III* to draw social and political parallels between what it meant to be an American, and who gets to claim full American citizenship, political or artistic, at pivotal moments in the country's history. *Making American Artists*, therefore, not only tells the stories of American art and artists, but also offers a unique mirror to US political and social history. As elucidated by the essays in this volume, PAFA's collection remains one of the most diverse historic collections in the country. Having collected and exhibited works by or educated women artists from Sarah Miriam Peale (pl. 7) to Laura Wheeler Waring, and Black artists from Henry Ossawa Tanner to Barkley L. Hendricks, PAFA also celebrates the work of artists, from Harriet Hosmer to Marsden Hartley (pl. 60), Violet Oakley (pl. 71), and Sonja Sekula, who would today be considered part of the LGBTQ+ community

PAFA's founders created an academy and a museum at the same time, so that a synergy existed and still exists between the creation and display of art. *Making American Artists* recognizes that, as a center of artistic excellence and stimulation, PAFA set out to encourage and train American artists, and its collection represents a distinctive picture of the nation and its artistic heritage.

1 Charles McIlvaine, "The Pennsylvania Academy of the Fine Arts," *The Quarterly Illustrator* 2, no. 5, (January–March, 1894): 10–11.

2 Ibid., 10.

3 For some examples of recent, more expansive and critical approaches to American art history published since 2005, the year of PAFA's 200th anniversary, and the time that the last survey of the collection was published, see Wendy Bellion, "The Return of the Eighteenth Century," *American Art* 19, no. 2 (2005): 2–10, https://doi.org/10.1086/444477; Kathryn Bunn-Marcuse, "Textualizing Intangible Cultural Heritage: Querying the Methods of Art History," introduction to Bully Pulpit, *Panorama: Journal of the Association of Historians of American Art* 4, no. 2 (Fall 2018), https://doi.org/10.24926/24716839. 1659; Emily Casey, introduction to "When and Where Does Colonial America End?," Colloquium, *Panorama: Journal of the Association of Historians of American Art* 7, no. 2 (Fall 2021), https://doi.org/10.24926/24716839.12682; Maggie M. Cao, "What is the Place of Empire in the History of American Art?," Bully Pulpit, *Panorama: Journal of the Association of Historians of American Art* 6, no. 1 (Spring 2020), https://doi.org/10.24926/24716839.9804; *The Blackwell Companion to American Art*, John Davis, Jennifer Greenhill, Jason Lafountain, eds. (Chichester, UK: Wiley-Blackwell, 2015); Jacqueline Francis, Naomi Slipp, Keri Watson, eds., introduction to "American Art History in the Time of Crises," Colloquium, *Panorama: Journal of the Association of Historians of American Art* 7, no. 1 (Spring 2021), doi.org/10.24926/24716839.11897; Karl Kusserow, "Ecocriticism," introduction for Bully Pulpit, *Panorama: Journal of the Association of Historians of American Art* 5, no. 1 (Spring 2019), https://doi.org/10.24926/24716839.1703; Angela L. Miller et al., *American Encounters: Art, History, and Cultural Identity* (Upper Saddle River, NJ: Pearson Education, 2008), available as a free, open-source download at https://openscholarship.wustl.edu/books/39/ ; Kirsten Pai Buick, "Seeing the Survey Anew: Compositional Absences that Structure Ideological Presences," *American Art,* 34, no. 3 (Fall 2020): 24–30; *Seeing America* - A portal to American art and history created by Smarthistory with 17 leading museum collections. https://smarthistory.org/seeing-america-2/.

4 John Davis, "The End of the Century: Current Scholarship on the Art of the United States," *The Art Bulletin* 85, no. 3 (September, 2003): 546.

5 Julia Jacobs, "Female Artists Made Little Progress in Museums Since 2008, Survey Finds," *New York Times,* September 19, 2019, https://www.nytimes.com/2019/09/19/arts/design/female-art-agency-partners-sothebys-artists-auction.html .

6 Stephen May, "An Enduring Legacy: The Pennsylvania Academy of the Fine Arts, 1805–2005," in *Pennsylvania Academy of the Fine Arts: 200 Years of Excellence*, (Philadelphia: Pennsylvania Academy of the Fine Arts, 2005), 12.

7 Ibid., 14.

8 Ibid., 16.

9 Elizabeth Johns, "Thomas Eakins and 'Pure Art' Education," *Archives of American Art Journal* 30, no. ¼, A Retrospective Selection of Articles (1990): 71–76.

10 Ibid., 19.

11 Ibid.

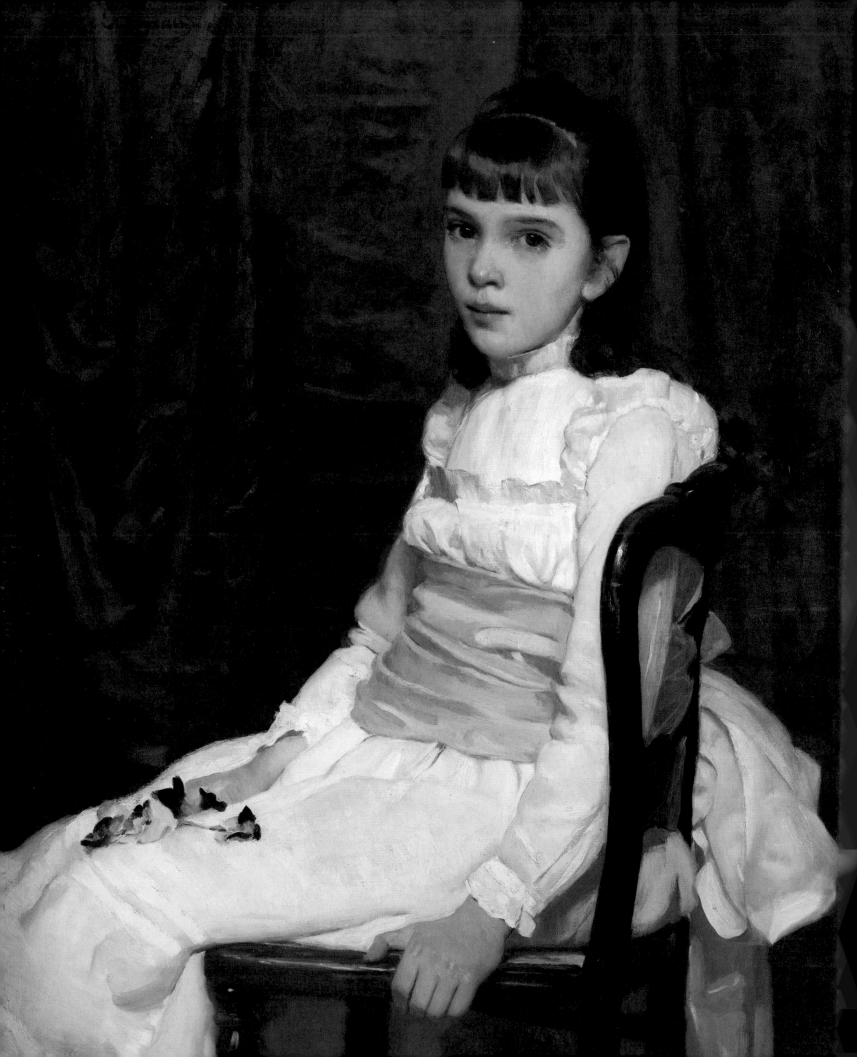

"WOMEN IN ART": WOMEN'S ARTISTIC NETWORKS IN PHILADELPHIA

ANNA O. MARLEY

At the turn of the twentieth century, the famed Gilded Age American painter and teacher William Merritt Chase declared in *Ladies Home Journal* "that genius has no sex,"[1] refer- ring to his talented women students. Chase's colleague Cecilia Beaux, the first female full-time professor of painting at the Pennsylvania Academy of the Fine Arts (PAFA), similarly expressed the hope that the hour was near when "the term 'Women in Art' will be as strange sounding a topic as 'Men in Art' would be now."[2] While these two statements reveal much about the expanding professional ambitions and advancement of women artists in the late nineteenth and early twentieth centuries, Beaux's quote— and the fact that her artistic reputation is nowhere near as familiar as that of her con- temporary and rival Mary Cassatt or that of her male contemporary Chase—demon- strates that scholarship still has far to advance in the study of American women artists.

PAFA, the first museum and art academy established in the United States, has the remarkable distinction of having actively exhibited and purchased the work of women artists since its first annual exhibition in 1811—where PAFA director Joseph Hopkinson wished to include "the products of female genius."[3] Foregrounding a history

of professional women artists in the United States, it becomes apparent why it is no accident that notable women artists like Cassatt and Beaux came from Philadelphia and studied at PAFA. For example, Patience Lovell Wright (fig. 1), who is often considered America's first professional sculptor, led directly to the artistic foundation of PAFA. Her life-size wax portraits, precursors to the work of Marie Tussaud, are composed of tinted wax and adorned with clothes and glass eyes. Her "Head of Washington, modeled from Life" (pl. 2) has a Philadelphia provenance and was exhibited in PAFA's annual exhibition in 1852.[4] Wright and George Washington had exchanged letters in the 1780s and he expressed the desire for her to create a wax portrait of him based on life modeling done by her son Joseph, who remained in Philadelphia while she worked in London.[5] Today we attribute the bust to Wright, though it could have also been made by her sister or one of her four children. After her husband died in 1769, Wright turned to art to support herself and her family. Joining forces with her sister Rachel Wells, Wright found success creating wax replicas of famous people. She modeled wax portraits of prestigious subjects such as the King and Queen of England, George Washington, and Benjamin Franklin. In addition to working with her sister, she trained her son Joseph, and he in turn trained sculptor William Rush, a founding artist member of PAFA.

Among the women included in PAFA's first annual exhibitions were Anna Claypoole Peale (fig. 2), Margaretta Angelica Peale (pl. 55), and Sarah Miriam Peale (pl. 7), the daughters of painter James Peale and nieces of the famed co-founder of PAFA, Charles Willson Peale. Anna was one of the most successful miniature painters in Philadelphia, completing more than 150 over her career and traveling up and down the eastern coast of the United States to obtain commissions.[6] The middle sister, Margaretta, chose to focus on still life painting, while the youngest, Sarah Miriam, followed in her

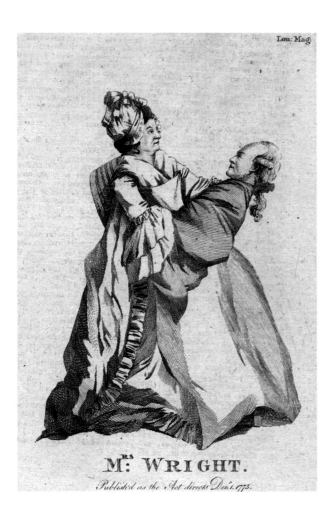

FIG. 1. Unidentified artist, *Patience Lovell Wright*, 1775. Etching on paper, 4¹⁵⁄₁₆ × 3¹¹⁄₁₆ in. National Portrait Gallery, Smithsonian Institution, NPG.78.261.

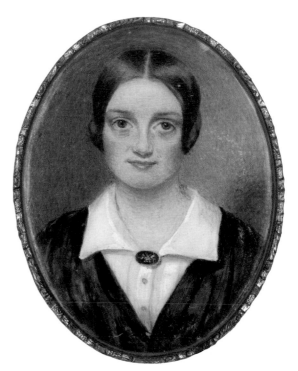

FIG. 2. Anna Claypoole Peale (American, 1791–1878), *Madame Lallemand*, 1810s. Watercolor on ivory, 1⅞ × 1½ in. Pennsylvania Academy of the Fine Arts, Philadelphia, Gift of Charles Hare Hutchinson, 1898.10.

FIG. 3. Rosalie Kemble Sully (American, 1818–1847), *Charlotte Cushman*, 1844. Miniature on ivory, 2 × 1½ in. Folger Shakespeare Library.

cousin Rembrandt Peale's footsteps as a portrait painter in oil, ultimately supporting herself through her art from the 1820s to the 1870s in both Baltimore and St. Louis.

One of the reasons for the Peale women's success was their access to family networks of artistic training and patronage. This was similarly the case for Jane Cooper Sully Darley, the daughter of Thomas Sully. A celebrated artist in Philadelphia, Darley exhibited at PAFA from 1825 to 1860, following in her father's footsteps as one of the city's most popular portrait painters. Familial artistic networks would continue to help Philadelphia women achieve success throughout the nineteenth century, playing a decisive role in the careers of Cassatt, Beaux, and Emily Sartain.

Outside of artistic family dynasties in Philadelphia, other significant arenas of success for women artists took shape in the mid-nineteenth century, including the burgeoning popular press and the neoclassical sculptural world of Italy. Women artists who participated in these fields were often best known not through their original art—oil or watercolor paintings or clay sculptures—but instead by their reproductions, such as lithographs, chromolithographs, and Italian marble sculptures.[7] By the mid-nineteenth century, American sculptors had long worked in Florence and Rome, where access to marble quarries and examples of ancient and Renaissance sculpture were readily at

hand. One of the best-known and most successful members of the group of independent American women neoclassical sculptors living in Italy in the 1850s and 1860s was Harriet Hosmer. In 1852, Hosmer traveled to Rome with the actress Charlotte Cushman, who had previously been in an intimate relationship with Thomas Sully's daughter Rosalie Kemble Sully (fig. 3). Hosmer remained in Rome, becoming one of the foremost American women sculptors of the nineteenth century. There, she lived and worked with a group of progressive, expatriate women artists, known for their independent lifestyles, gender-bending fashion, and same-sex relationships. Besides being on view in Rome, her works were also presented in the leading exhibitions of the period in the United States.[8]

FIG. 4. Harriet Hosmer with her assistants and carvers in the courtyard of her tudio in Rome, 1867. Albumen print, 11⅜ × 16½ in. National Gallery of Art Library. Hertzmann Collection of Photographers of American Artists.

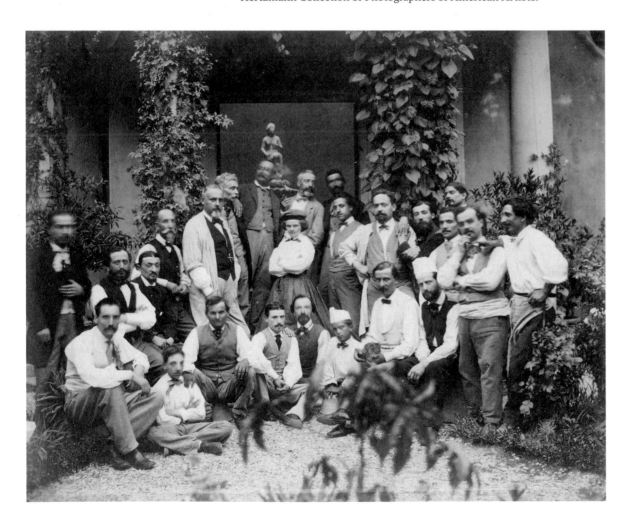

Arriving in Italy after having studied in St. Louis and her native Massachusetts, Hosmer became a celebrity in Rome (fig. 4), the traditional endpoint of the European Grand tour; she was famously visited in her studio by the Prince of Wales, who purchased one of her sculptures as a souvenir. He chose a copy of *Puck on a Toadstool* (c. 1856, pl. 11), wherein she captures the impish spirit of the Shakespearean sprite in the form of a naughty toddler ready to fling a beetle at the nearest hapless passerby. In 1857, Hosmer wrote of her sculpture *Puck* that "Someone has justly said: 'This little forest elf is the very personification of boyish self-will and mischief. With his right hand he grasps a beetle, and seems about to throw it; with his left he presses unconsciously a lizard. In all the lines of the face, in all the action of the body, gleams forth the mischievous self-will of a being scarcely aware of the pain he causes, whilst rollicking in the consciousness of his tiny might.'"[9] One of her most famous sculptures, similarities abound between the mischievous Puck and the diminutive, self-willed, shape-shifting artist herself, who was described by her contemporaries as "willful," "like a little boy," and "queer."[10]

Through advances in printmaking technologies, a growing number of Americans had access to fine-art reproductions for display in their homes. For example, Lilly Martin Spencer was one of the most successful artists employed by the publishers Currier and Ives.[11] Spencer trained in Cincinnati and worked both there and in New York City and New Jersey. Unlike the Peale sisters, Spencer married, and her husband stayed at home to help raise their thirteen children so that she might continue her artistic career. *Mother and Child by the Hearth* (1867, pl. 66) is a classic example of Spencer's oeuvre. Filled with warm sentiment and charm, it shows a modern American Madonna and Child by the light of a middle-class domestic hearth. Currier and Ives made thousands of reproductive engravings of similar domestic settings after Spencer's paintings, which often featured herself and her children.

Another painter whose works were widely reproduced as chromolithographs and thus accessible to a broad public was Mary Russell Smith, who exhibited her enormously popular sentimental paintings of chickens at PAFA from 1859 to her untimely death in 1878 (pl. 57). She was the daughter of landscape and theatrical scenery painter Russell Smith and artist Mary Priscilla Wilson Smith. Mary and her brother, Xanthus Russell Smith, both became professional artists. Before her death at the age of thirty-six, Mary and her father established the Mary Smith Prize for women artists exhibiting in PAFA's annual exhibitions, using the proceeds from the sale of her paintings to fund the award. This was one of the first professional cash prizes awarded to a woman artist in the country and the award created a network of women recipients stretching almost 100 years. The first woman to receive the prize in 1879 was Susan MacDowell Eakins and the last was Edna Andrade in 1968. Noted Philadelphian Cecilia Beaux won the Mary Smith prize four times.

Paris, with its famous salons, had supplanted Rome as the epicenter of the art world by the 1870s. It was here that the next generation of professional American artists proved their mettle. While female students had been enrolled at PAFA since 1844 to study from

"the antique," or plaster casts, in the 1860s they were still not permitted to study the live human figure. Around this time, a group of female students, including Mary Cassatt, formed their own group to model for each other.[12] Cassatt, the daughter of a wealthy Philadelphia railroad magnate, began her studies with Jean-Léon Gérôme in France in the 1860s, as did her fellow Philadelphian Thomas Eakins. Upon her return to Philadelphia following the outbreak of the Franco-Prussian War, she became a close friend and studio mate of Emily Sartain, the daughter of Philadelphia's leading printmaker John Sartain and who was emerging as one of the city's most successful women artists (fig. 5).[13] The friendship between Cassatt and Sartain continued through their studies in Parma (Italy) and Paris, hearkening back to the earlier familial networks of the Peale sisters. In looking at paintings by each artist from the 1870s, one can see similarities in the application of paint, and the loose, expressive brushstrokes influenced by studying European masters. *Bacchante* (pl. 44), completed by Cassatt when the two artists were in Parma in 1872, and Sartain's *Study* (pl. 13), probably a portrait of her sister-in-law Harriet painted in Philadelphia in 1878, speak to each other in scale and technique. However, the artists went their separate ways in the mid-1870s, Sartain returning to Philadelphia, and Cassatt staying on in Paris, where she met Edgar Degas and subsequently began exhibiting with the French impressionists. By the 1880s, Cassatt's painting style had thoroughly aligned with this group, while Sartain had become the respected principal of the Philadelphia School of Design for Women (now Moore College of Art and Design) and a founder in 1897 of The Plastic Club, the first women's art club in the United States.[14]

Life drawing—or drawing from a live model—had long been considered an essential part of PAFA's curriculum. For many years, women were excluded from these classes, as it was considered inappropriate to expose women to the nude figure. In 1876, Alice Barber Stephens joined many of her colleagues in petitioning for more life drawing classes for women. These students were eventually successful, although the classes remained separated by gender. In 1879, Stephens painted and engraved *The Women's Life Class* (pl. 14) for an article on Philadelphia art schools for *Scribner's Monthly* magazine. The work provides a glimpse of what the classes at PAFA were like—while still revolutionary, the only nude models were women, and the male models were mostly draped. Stephens's friend and colleague, Susan MacDowell Eakins, sits at the front of the class. Later, Stephens enjoyed a successful career as an illustrator; she left the Academy in 1880 to work as a commercial artist full-time. Throughout her life, Stephens continued to advocate for the careers of women artists, as both an instructor at the Philadelphia School of Design for Women, and as one of the founders, with Emily Sartain, of The Plastic Club.

In Boston, another network of women artists with connections to PAFA emerged, one that also extended across the Atlantic to Paris. Ellen Day Hale, who studied at PAFA with Thomas Eakins, was one of the most internationally successful students of the Boston school.[15] An independent artist from a long line of accomplished women, Hale also served as mentor for younger artists in Paris, including Anna Elizabeth Klumpke, whom she had

FIG. 5. Emily Sartain, c. 1895–1900. Photographed by Conrad Haeseler (American, 1875–1962). Platinum print, 6⅜ × 5 in. The Pennsylvania Academy of the Fine Arts' Archives, Philadelphia. Sartain Family papers, MS.033.

FIG. 6. Cecilia Beaux seated near *Les Derniers Jours d'Enfance*, (The Last Days of Childhood), c. 1885. Gelatin silver print, 6¼ × 8¾ in. The Pennsylvania Academy of the Fine Arts' Archives, Philadelphia. Cecilia Beaux papers, MS.060.

befriended on her arrival in the city.[16] Klumpke's *In the Wash-House* (1888, pl. 68), one of her greatest works, is a salon-size painting that bears the proud inscription "Paris."[17] The artist donated the canvas to PAFA two years after it was painted. Born in San Francisco, Klumpke later studied in France and became the life partner of the famed French animal painter Rosa Bonheur. *In the Wash-House* focuses on a group of young women laughing and working together. Steam rises from the large washing basin in the center of the canvas, fogging the large windows, and silhouetting the strong, solid, and warm women. It was the first painting by a woman artist to win the prestigious Temple Gold Medal at PAFA, a prize which had previously only been awarded to male artists—indeed in the entire history of the prize only three women were awarded it after Klumpke: Cecilia Beaux for her painting *Mother and Daughter* (1898, Pennsylvania Academy of the Fine Arts), and Helen Frankenthaler for *Tobacco Landscape* in 1968.

Back in the United States, the Progressive Era—a period of social activism and political reform across the country spanning the 1890s to the 1920s—ushered in a spate of

opportunities for professional women artists. This period coincided with the popularity of the Arts and Crafts movement, growth in the professionalization of certain fields for women—such as popular illustration and landscape architecture—and the movement for universal women's suffrage. Philadelphia, and PAFA in particular, continued to be a leader in women's art education.

In 1895, Cecilia Beaux, who had studied both at PAFA and in Paris, became not only the first full-time female professor at PAFA, but at any co-educational art school in the United States.[18] Beaux, like most of the artists discussed here, benefited from networks of family and artistic friends. At PAFA, she studied painting under her aunt Catherine Ann Drinker and the painter William Sartain, the brother of Emily Sartain, before she traveled to France to pursue additional training at the Académie Julian. After winning acclaim at the French salon with her painting *Les derniers jours d'enfance* (1883–5, fig. 6), Beaux returned to Philadelphia to become one of the most successful portraitists of the era, rivaled only by Chase and John Singer Sargent. Her 1887 painting, *A Little Girl* (pl. 15), is one of her masterpieces. Sweet, but not saccharine, the sitter Fanny Travis Cochran looks out forthrightly at the viewer in this arresting portrait.

Neither Beaux nor her rival Mary Cassatt had children of their own. A circa 1891 canvas by Cassatt depicting a mother and baby appears unfinished (pl. 69). The faces of the figures are in a state of near completion, while the rest of the image is rendered as a quick, energetic outline. 1891, the year this work was completed, was a significant year for Cassatt, in which she was busy preparing for her first one-person show and working on a portfolio of ten color prints. The canvas is signed at lower left "to Adolph Borie/ Mary Cassatt." Adolphe Borie, a PAFA alum, was a prominent artist and teacher in Philadelphia, and was connected with a circle of early modernists in the city. Though at this time Cassatt was firmly embedded within the impressionist group in Paris, she continued to influence the American art world, working with American women collectors to bring modern French painting to the United States, and specializing in her signature paintings, prints, and pastels of women's interior lives.

Similarly, Bessie Potter Vonnoh specialized in scenes of mothers and children. Vonnoh, a native of Saint Louis, began her studies at the Art Institute of Chicago when she was fourteen. She enjoyed a successful forty-year career making sculptures of upper-class women at different stages of life engaged in everyday activities. After her marriage to the painter and PAFA instructor Robert Vonnoh in 1899, the couple moved to Rockland Lake, New York. From 1900 onward, she exhibited widely at national and international exhibitions. Though she and Robert never had children, *Young Mother* (1896, pl. 70)— the first of her works to treat the theme of motherhood—became her best-selling work. The sculpture was reproduced in over thirty castings as well as in numerous plaster copies. Vonnoh's impressionistic technique is marked by extremely subtle surface modulations. Facial features are merely suggested and eyes are indicated by shallow depressions, producing an idealized conception of the bonds between mother and child.

Beaux was not only known for her portraits, but also for her role as a teacher. Violet Oakley was one of her most successful students. After studying at PAFA, Oakley had the career of a Renaissance woman, creating successful illustrations for the popular press—such as *June* (c. 1902, pl. 71)—and becoming the first female muralist in the United States when she received the commission to paint the murals for the State Capitol building in Harrisburg, Pennsylvania.[19] Like many of the women before her, it was not only the mentorship of a woman, Beaux, that helped her succeed, but also the network of women artists with whom she lived and worked for the remainder of her career. As a young illustrator in Philadelphia, Oakley shared a home and studio, Cogslea, with two other illustrators, Jessie Willcox Smith and Elizabeth Shippen Green; together, they were known as the Red Rose Girls, and this interdependent relationship enabled them to support each other emotionally and financially (fig. 7).[20]

FIG. 7. Elizabeth Shippen Green, Violet Oakley, Jessie Willcox Smith, and Henrietta Cozens in their Chestnut Street studio, c. 1901. Photographic print, 4 11/16 × 6 11/16 in.
Archives of American Art, Smithsonian Institution Washington, DC, 20560, item ID 7664.

While Beaux was teaching at PAFA, Chase joined her on the educational staff from 1896 to 1909. Instructing over five hundred female students at PAFA, he also taught at the Art Students League, New York, and his own Shinnecock Hills Summer School of Art on Long Island.[21] Elizabeth Sparhawk-Jones represents another of Chase's remarkable PAFA students, shown in a portrait painted by her classmate Alice Kent Stoddard (pl. 21). While still a student at PAFA, Sparhawk-Jones painted *The Market* (c. 1905), an ambitious and robust canvas focused exclusively on women buying and selling wares in a public market. In the 1910s, Sparhawk-Jones continued to develop this theme in a series of paintings set in Philadelphia's Wanamaker Department Store, such as *Shop Girls* (c. 1912, fig. 8), which focuses on young professional women serving wealthy shoppers. Her focus on women, who, like her, are making their way in a professional consumer marketplace, is unique for her empathic depiction of the "girls."[22]

In addition to mentoring painters, Chase was a close friend and supporter of the careers of women sculptors, including his friend Bessie Potter Vonnoh and PAFA student May Howard Jackson.[23] Jackson was the first African American woman to receive a full scholarship to attend PAFA, where she studied both painting (pl. 92) and sculpture (pl. 47). Georgia O'Keeffe, who studied with Chase in New York at the Arts Students League, described his instruction as "fresh, energetic, and fierce," and that language could aptly describe both the painting of Sparhawk-Jones and the sculpture of Jackson.[24]

Though Philadelphia was a leader in women's artistic education, it was not the only locus for powerful networks of women artists. As scholar Erica Hirshler has explored in depth, Boston was also a center for women's artistic education. Many of the artists of the so-called Boston School exhibited regularly at PAFA, including Margaret Foster Richardson, Elizabeth Okie Paxton, and Lilian Westcott Hale. PAFA not only presented the art of these women, but supported their careers by purchasing works. Richardson's *A Motion Picture* (1912; pl. 23) was shown at PAFA in 1913, and Hale's *When She Was a Little Girl* (c. 1918; pl. 25) was likewise exhibited, and then added to PAFA's collection. Though Paxton's *Sick a-Bed* (pl. 74) was on view in 1916, PAFA did not purchase it until one hundred years later. All three of these paintings offer atmospheric psychological portraits of their sitters. However, Richardson's *A Motion Picture* is remarkable for its modernity, both in its allusion to the explosion of the popularity of the medium of motion pictures in the 1910s and in the artist's straightforward presentation of herself as an unabashedly independent, professional artist.[25]

This unique self-portrait reflects changing attitudes toward women in the early twentieth century as well as the expansion of opportunities clearly embraced by the artist. Depicting herself as a working artist, dressed in a painting smock with brushes in each hand, Richardson strides across the canvas into the light, hardly slowing to meet the eye of the viewer. Richardson's direct gaze, knowing smile, and the work's sense of movement and vitality convey a self-confidence and professionalism associated with the era's so-called "New Woman." In contrast to more decorative examples of contemporary

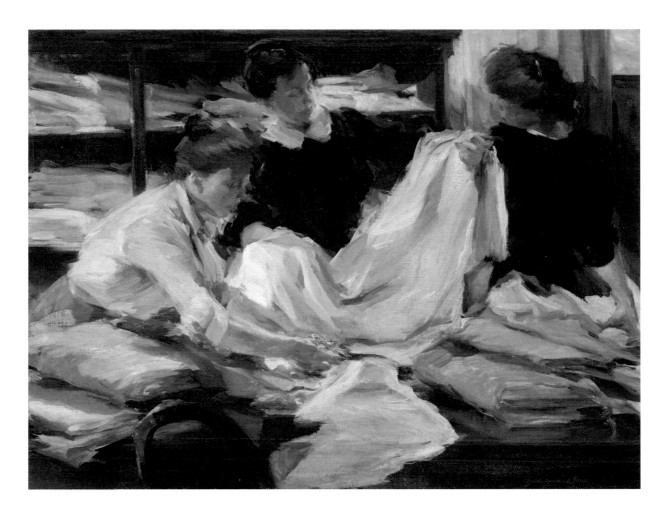

FIG. 8. Elizabeth Sparhawk-Jones (American, 1885–1968), *Shop Girls*, 1912. Oil on canvas, 38 × 48 in. Art Institute of Chicago, Friends of American Art Collection, 1912.1677.

femininity, Richardson chose to portray herself actively engaged in her profession without concession to fashion—she wears eyeglasses, a no-nonsense hairstyle, and a masculine collar and tie.

A native of Winnetka, Illinois, Richardson moved to Boston at nineteen to study art with the "Boston School" impressionists Joseph De Camp and Edmund C. Tarbell. Primarily a portraitist, she found early success and won a number of awards. Richardson favored strong, active female sitters, and was praised for her ability to capture subjects so honestly. At the same time, many critics thought her portraits were truthful to the point of being unflattering. Richardson continued to receive commissions and exhibit widely until 1930, at which point her style went out of professional favor.

Benefitting from the generation of professional women artists who came before them, the network of women artists born in the 1870s and 1880s have become synonymous with modernism in the United States in New York and Philadelphia.[26] Florine Stettheimer, born into a wealthy New York family in 1871, studied at the Art Students League before

FIG. 9. Meta Vaux Warrick Fuller (American, 1877–1968), *Ethiopia Awakening*, c. 1921.
Paint on plaster, 13 × 3½ × 3⅞ in. Collections of the Smithsonian National Museum
of African American History and Culture, Gift of the Fuller Family, 2013.242.1.

obtaining further training in Munich and Paris. Upon the outbreak of World War I, her family returned to New York and quickly came to dominate the city's progressive art circles. The Stettheimer salon attracted major avant-garde figures in the 1920s and 1930s, including Marcel Duchamp, Elie Nadelman, and Carl Van Vechten. In *Picnic at Bedford Hills* (1918; Pennsylvania Academy of the Fine Arts, Philadelphia), Stettheimer portrays herself and her sisters relaxing with Nadelman and Duchamp in a self-consciously "naïve" modern landscape, while laborers plow the vibrantly flattened neighboring field.[27]

Georgia O'Keeffe was at that time living and working in the same progressive circles of New York City. Her mature style of modernism is influenced less by American folk art and more by the international modernism that was part of the vernacular of the circle of her husband, Alfred Stieglitz—of which she was the only female member. Raised in a family that stressed the education of women, O'Keeffe attended the Art Institute of Chicago before moving to New York to study at the Art Students League with Robert Henri and Chase. At the Art Students League, O'Keeffe won a coveted prize for still life in Chase's class. In 1916 her paintings came to the attention of Stieglitz, whose New York gallery was an important venue for the European and American avant-garde. Stieglitz's gallery hosted O'Keeffe's first solo show, and he became her most vigorous promoter until his death in 1946. In 1924, O'Keeffe and Stieglitz married, and her work appeared in an exhibition of modern painting at PAFA. Stieglitz (as well as O'Keeffe herself) was happy to identify her as *the* modern woman artist.[28] *Red Canna* is among the earliest of her enlarged, abstracted flower paintings of this same period (1923, pl. 61). Despite its small size, the work demonstrates her interest in establishing a new kind of modern still life that focused on the beauty of the natural world, with emphasis on vibrant color and no references to atmospheric effects or realistic details. Of course, there were many other successful and talented women working before and at the same time as O'Keeffe, yet her self-promotion was so successful throughout the twentieth century that, in the minds of many twenty-first-century art lovers, she is still the preeminent American woman artist.[29]

If Stettheimer and O'Keeffe were the doyennes of the downtown art scene, an equally important group of women professional artists were molding the art scene uptown in Harlem. Though both the sculptor Meta Vaux Warrick Fuller and the painter Laura Wheeler Waring were from Philadelphia, their work is often associated with New York City and the Harlem Renaissance, due to their professional relationships with the leaders of that movement. Rather than enrolling at PAFA, Fuller studied at the Pennsylvania Museum and School for the Industrial Arts. Afterward, she traveled to Paris, where she was taken under the wing of fellow Philadelphian Henry Ossawa Tanner, who introduced her to American sculptor Augustus Saint-Gaudens and French sculptor Auguste Rodin, both of whom were to have a profound influence on Fuller.[30] While her work in Paris was decidedly symbolist, she is best known for her later works, including her masterpiece *Ethiopia Awakening* (1921, fig. 9), which shows an allegorical figure of Ethiopia arising from centuries of slumber in the shroud of an Egyptian mummy, a fitting symbol for the Harlem Renaissance.

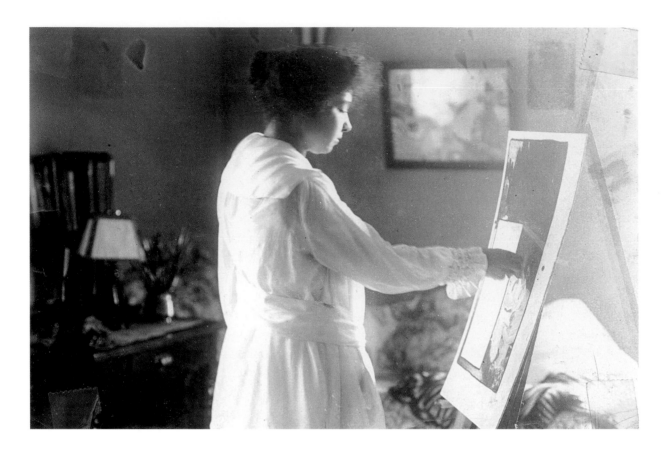

FIG. 10. Laura Wheeler in her studio at Cheyney State Teachers College. Photographic print. Courtesy of the Moorland-Spingarn Research Center, Manuscript Division, Howard University, Washington, DC.

Waring (then Wheeler) studied at PAFA with Chase before, in 1914, becoming the first African American to win the coveted Cresson Memorial Scholarship; this enabled her to continue her studies in Paris at the Académie de la Grande Chaumière, until her trip was cut short by the outbreak of World War I (fig. 10). The same fresh, energetic, and fierce technique that O'Keeffe attributed to Chase's instruction can be seen in Waring's *Anna Washington Derry* (1927, see Byrd, fig. 3). A talented portraitist, Waring received national accolades for her series of portraits of African American cultural leaders for the Washington, DC–based Harmon Foundation.[31] Waring met Derry when she was head of the art and music department at Cheyney State Teachers College, the first historically Black college and university (fig. 10); the painting is an intimate half-length portrait of a woman by a woman, a format that Waring uses again in *The Study of a Student* (c. 1940s, pl. 29). It seems that many women artists of the era preferred this style for representations of their friends, peers, and colleagues, rather than the full-length portraits for which they might have received commissions.

As women's professional and political independence grew in the era of agitation for universal women's suffrage, so too did their access to subject matter, such as landscapes and cityscapes, which had once been the exclusive territory of male artists. Even as women

claimed these broader spaces, they continued to innovate in more traditional genres, like portraiture and still life, as the modernist works collected through the John Lambert Fund at PAFA in the first half of the twentieth century clearly demonstrate. The early twentieth century opened up new possibilities for women working in the traditionally male-dominated mode of landscape painting. As the idea of the "new woman"—educated, athletic, and independent—took hold, artist's colonies, public parks, and public beaches became spaces where modern women artists could work. While May Howard Jackson depicted an urban landscape, the hilly Morris Heights in the West Bronx (pl. 92), Marianna Sloan painted a popular seaside resort filled with families at leisure (pl. 93), and Helen Fleck Seyffert painted the mountains in a modernist symphony of color (pl. 94) that would rival the work of her contemporary Marsden Hartley (pl. 60). Likewise, the urban scenes of Hilda Belcher (pl. 75) rival the Ashcan cityscapes of George Bellows (pl. 91) and Edward Hopper (pl. 76).

In the 1930s, with the advent of the Great Depression and the Works Progress Administration, women artists, like their male counterparts, turned to social realism as a predominant mode of expression. Alice Neel's *Investigation of Poverty at the Russell Sage Foundation* (1933, pl. 50) and Isabel Bishop's *Young Woman* (1937, pl. 27) align with works by their contemporaries Reginald Marsh (pl. 78) and William J. Glackens (pl. 77) in their focus on lives of the working classes, and young professional women in New York City, respectively. Neel made her first major works in the midst of the Great Depression. In the 1930s she was active in a circle of political-minded radical artists, writers, and intellectuals in New York. Although she eventually became famous as an insightful and uncompromising portraitist, her interest in depicting humanity originated in this period, as in this painting where a group of unsympathetic administrators from the Russell Sage Foundation watch a weeping woman beaten down by poverty.[32]

Bishop was born in Cincinnati but moved East in 1918, where she enrolled at the New York School of Applied Design for Women and then the Art Students League, beginning in 1920. In the city—especially in the area around Union Square—Bishop was inspired by the bustle of urban life, particularly by the young women of New York, who were entering the work force in ever increasing numbers. In paintings and prints, Bishop explored both the women and the men of New York, as they interacted with their jobs, each other, and the city. Although Bishop's subject may be modern, the technique she chose for this painting recalled those of the old masters, whose work she discovered after a trip to Europe in 1931. The use of egg tempera (the combination of pigments dissolved in egg yolk) was employed in European painting before the widespread dominance of oil-based pigments in the seventeenth century. In using this technique Bishop sometimes spent nearly an entire year working on a single painting, belying the simple ephemeral quality of the finished work.

The impact two world wars had on American art cannot be underestimated, particularly as abstract expressionism took hold on the American art world. Janet Sobel and

Sonja Sekula were both American artists born in Europe, and both were connected with Peggy Guggenheim, a collector and gallerist known for promoting the so-called New York School of painting. Sobel, a self-taught artist, stated of her painting *Invasion Day*, "The air was charged with the thought of invasion, with its attendant fears and hopes," and painted it shortly before the Allied invasion of Europe on June 6, 1944.[33] *Invasion Day* was included in PAFA's 140th Annual Exhibition in 1945, and was purchased through the Academy's John Lambert Fund, which acquired works by "artists who had not received any considerable amount of professional recognition."[34]

Donated to PAFA by the estate of the famed gallerist Betty Parsons, *The Rains* (pl. 102) was inscribed on the back in pencil by Sonja Sekula with the caption "The Rains (remembering Uruapan)," according to an undated conservation report in PAFA's artists files. Uruapan is a pre-Hispanic city in Mexico, which Sekula may have visited earlier in the 1940s. This connects the painting to a gouache in the collection by the artist called *Memory of the Rains in Uruapan* (fig. 11). An out lesbian in a time of intense homophobia, Sekula was working across borders, both in her transatlantic identity and peregrinations between the United States and Switzerland, as well as in the pictorial languages of American expressionism and European surrealism; works such as *The Rains* have been interpreted in that latter context.[35]

The second-wave feminist movement of the 1960s and 1970s is an important backdrop for the recasting of the figure in the work of Elizabeth Osborne and Joan Brown.[36] Born in Philadelphia, Osborne enrolled at PAFA in the mid-1950s. In 1961, she joined the faculty, where she continued to teach until retiring in 2011. *Woman with Red* (pl. 33) shows a woman in a domestic interior, a popular subject of genre scenes and portraiture which recalls the work of Lilly Martin Spencer in the 1860s. However, this 1960s painting balances realism and Color Field abstraction, playing with representation and abstraction. Since the beginning of her career, Osborne incorporated and interpreted core issues of modern painting, from the staining of raw canvas to the flattening of planes, from a schematic stylization of forms to the pragmatic investigation of the medium of paint itself. As Osborne's 1960s work recasts nineteenth-century genre scenes into a modernist paradigm, Joan Brown's 1977 *Self-Portrait* (Pennsylvania Academy of the Fine Arts) takes on the monumental artistic self-portrait dating back to Peale's *Artist in His Museum* (pl. 8). Brown, who was part of the Bay Area Figurative movement, was influenced by the immediacy and vibrancy of abstract expressionist handling of color and flat planes. This work seems to ridicule the very idea of monumental self-portraiture. Brown depicts herself painting a still life, a genre traditionally associated with women, while wearing a 1950s inspired dress and improbably white gloves and high heels. Like Osborne she juxtaposes abstraction and figuration, but also humor, to challenge conventional narratives of artistic "genius" through poking fun at the heroic artist model.

This account of the careers of some of the many individuals championed by PAFA, from the first annual exhibition to the nation's centennial in 1976, highlights the extent to which collaborative working and personal relationships among them bolstered their collective

FIG. 11. Sonja Sekula (Swiss, 1918–1963), *Memory of the Rains in Uruapan*, 1949.
Gouache and graphite on off-white wove paper, 16⅞ × 13¹³⁄₁₆ in. The Pennsylvania Academy
of the Fine Arts, Philadelphia. Gift of the Betty Parsons Foundation, 1985.51.

professionalization, success, and legacy. In the twenty-first century, PAFA remains a
pioneer in its support of women artists.[37] Aided by recent transformative gifts such as the
Linda Lee Alter Collection of Art by Women, along with focused acquisitions over the
past decades of work by women active from the eighteenth into the twenty-first centuries,
PAFA continues to fulfill its steadfast mission to champion "products of female genius."

1 Quoted in Erica Hirshler, "Old Masters Meet New Women," in *William Merritt Chase: A Modern Master* (New Haven and London: Yale University Press, 2016), 25.

2 Sylvia Yount, *Cecilia Beaux: American Figure Painter* (Berkeley: University of California Press, 2007), 11.

3 For an introduction to women artists at PAFA, see Anna Havemann, "Expanded Horizon: Female Artists at the Pennsylvania Academy of the Fine Arts during the Course of the Nineteenth Century," in *The Female Gaze,* ed. Robert Cozzolino (Philadelphia: Pennsylvania Academy of the Fine Arts and Marquand Books, 2013), 32.

4 See *The Annual Exhibition Record of the Pennsylvania Academy of the Fine Arts, 1807–1870,* (Madison, CT: Sound View Press, 1988), 1:261.

5 Washington wrote to Wright in 1783, "If the Bust which your Son made modelled of me, should reach your hand and afford your celebrated Genii any employment, that can amuse Mrs. Wright, it must be an honor done me,— and if your inclination to return to this Country should overcome any considerations, you will no doubt, meet a welcome reception from your numerous friends: among whom I should be proud to see a person so universally celebrated. . . ." Quoted in Parker Lesley, "Patience Lovell Wright, America's First Sculptor," *Art in America* 24 (October 1936): 154.

6 See Carol Soltis, *The Art of the Peales in the Philadelphia Museum of Art: Adaptations and Innovations* (New Haven: Yale University Press, 2017).

7 For more on the popularity of Prang chromolithographs, see Michael Clapper, "'I Was Once a Barefoot Boy!': Cultural Tensions in a Popular Chromo," *American Art*, (2002) 16:2: 17–39.

8 For a biography of Hosmer see Dolly Sherwood, *Harriet Hosmer: American Sculptor, 1830–1908* (Columbia and London: University of Missouri Press, 1991).

9 Harriet Hosmer, "Rome, Feb. 15, 1857," *Letters and Memories*, ed. Cornelia Carr (New York: Moffat, Yard and Company, 1912), 79.

10 For a discussion about Hosmer's lesbianism as related to her art and identity, see Vivien Green Fryd, "The 'Ghosting' of Incest and Female Relations in Harriet Hosmer's 'Beatrice Cenci'," *The Art Bulletin* 88, no. 2 (2006): 292–309. Accessed May 28, 2020. www.jstor.org/stable/25067246.

11 For a discussion of the importance of both the paintings by and reproductive prints after the work of Spencer, see Holly Pyne Connor, "The Flowering of Girlhood Narratives, 1850–1870," and Sarah Burns, "Making Mischief: Tomboys Acting Up and Out of Bounds," in *Angels and Tomboys: Girlhood in 19th-Century American Art* (San Francisco: Pomegranate, 2013), 10–27, 84–105.

12 Havemann, "Expanded Horizon," 35.

13 For a biography of Cassatt, see Nancy Mowll Mathews, *Mary Cassatt: A Life* (New Haven: Yale University Press, 1998). For the most comprehensive study of Cassatt's oeuvre, see Judith A. Barter, *Mary Cassatt: Modern Woman* (Chicago and New York: The Art Institute of Chicago and Harry N. Abrams, 1998). An illustrated timeline therein details the relationship and correspondence between Cassatt and Sartain, 331–34.

14 See Kristen Swinth, "Emily Sartain and Harriet Judd Sartain, M.D.: Creating a Community of Women Professionals," and Page Talbott, "The Sartain Family and the Philadelphia School of Design for Women," in *Philadelphia Cultural Landscapes: The Sartain Family Legacy* (Philadelphia: Temple University Press, 2000), 138–48, 161–74.

15 For the definitive publication on women of the Boston School, see Erica E. Hirshler, *A Studio of Her Own: Women Artists in Boston, 1870–1940* (Boston: MFA Publications, 2001).

16 For an excellent recent study of the American women working in Paris, see Laurence Madeline, *Women Artists in Paris, 1850–1900* (New Haven: Yale University Press, 2017).

17 This painting was originally exhibited at PAFA in 1889 as *A la Buanderie*.

18 For more on Beaux, see Sylvia Yount, *Cecilia Beaux: American Figure Painter* (Berkeley: University of California Press, 2007).

19 To learn more about Oakley, see Pat Likos, *A Grand Vision: Violet Oakley and the American Renaissance* (Philadelphia: Woodmere Art Museum, 2017), and Bailey Van Hook, *Violet Oakley: An Artist's Life* (Newark: University of Delaware Press, 2016).

20 Alice A. Carter, *The Red Rose Girls: An Uncommon Story of Art and Love* (New York: Harry N. Abrams, 2000).

21 Recent scholarly studies of groups of women artists of this period include Kelsey Frady Malone, "Sisterhood as Strategy: the Collaborations of American Women Artists in the Gilded Age," (PhD Dissertation, Art History and Archeology, MU, 2018); Marian Wardle, ed., *American Women Modernists: The Legacy of Robert Henri, 1910–1945* (New Brunswick: Rutgers University Press in association with Brigham Young University Museum of Art, 2005); Page Talbott and Patricia Tanis Sydney, *The Philadelphia Ten: A Women's Artist Group, 1917–1945* (Philadelphia: Galleries at Moore & American Art Review Press, 1998); Christine Jones Huber, *The Pennsylvania Academy and Its Women, 1850 to 1920* (Philadelphia: Pennsylvania Academy of the Fine Arts, 1973).

22 Elizabeth Carlson has persuasively compared Sparhawk-Jones's work to that of her male contemporary William J. Glackens, who similarly depicted women shopping at Wanamaker's, but centered his attention on the consumer rather than the worker. See Carlson, "The Girl Behind the Counter: Elizabeth Sparhawk-Jones and the Modern Shop Girl," *Panorama: Journal of the Association of Historians of American Art* 5, no. 5 (Spring 2019). https://doi.org/10.24926/24716839.1683. For a biography of Sparhawk-Jones see Barbara Lehman Smith, *Elizabeth Sparhawk-Jones: The Artist who Lived Twice* (Denver: Outskirts Press, 2010).

23 Julie Aronson, *Bessie Potter Vonnoh: Sculptor of Women* (Cincinnati: Ohio University Press, 2008).

24 Katherine M. Bourguignon, "The Performative Teaching of William Merritt Chase," in *William Merritt Chase: A Modern Master*, 35.

25 For more on this connection, see Katherine Manthorne, *Film and Modern American Art: The Dialogue Between Cinema and Painting* (New York & London: Routledge, 2019).

26 For more on women modernists in New York, see Ellen E. Roberts, *O'Keeffe, Stettheimer, Torr, Zorach: Women Modernists in New York* (West Palm Beach: Norton Museum of Art, 2016).

27 Stephen Brown and Georgiana Uhlyarik, *Florine Stettheimer: Painting Poetry* (New Haven: Yale University Press, 2017).

28 For more on O'Keeffe, see the work of Wanda Corn, including *Georgia O'Keeffe: Living Modern* (New York: Prestel, 2017) and *The Great American Thing: Modern Art and National Identity, 1915–1935* (Berkeley: University of California Press, 2001), 239–291.

29 In 2014, O'Keeffe's art made headlines around the world for being the most expensive by a woman, for example, "Georgia O'Keeffe painting sets auction record for female artist," *BBC News*, November 21, www.bbc.com/news/entertainment-arts-30142581.

30 Renée Ater, *Remaking Race and History: The Sculpture of Meta Warrick Fuller* (Berkeley: University of California Press, 2011).

31 No stand-alone catalogue exists on the work and life of Waring; however, her work is discussed in Lisa Farrington, "The Harlem Renaissance and the New Negro," in *Creating Their Own Image: The History of African-American Women Artists* (Oxford University Press: New York, 2004), 76–95. For an excellent recent article on Waring's painting of Derry, see Valerie Harris, "Life of a Portrait: Laura Wheeler Waring's *Anna Washington Derry*," *Pennsylvania Heritage* 45, no. 3 (Summer 2019): 16–25.

32 For more on Alice Neel see Kelly Baum and Randall Griffey, *Alice Neel: People Come First* (New York: Metropolitan Museum of Art, 2021).

33 Letter from Joseph T. Fraser Jr., secretary at PAFA, to Mosanne Magdol, Editorial Department, Collier's, January 24, 1946, 2., PAFA object files, Sobel, *Invasion Day*.

34 Ibid., 1.

35 Richard G. Mann, *Sekula, Sonja (1918–1963)* Encyclopedia Copyright © 2015, glbtq, Inc., Entry Copyright © 2005, glbtq, inc. Reprinted from http://www.glbtq.com.

36 Jodi Throckmorton, "A Different Approach: Joan Brown, Viola Frey, and the Feminist Art Movement," in *The Female Gaze,* 221–227. Also Robert Cozzolino, *Elizabeth Osborne: The Color of Light* (Philadelphia: PAFA and Bunker Hill Publishing Inc, 2009).

37 Julia Jacobs, "Female Artists Made Little Progress in Museums Since 2008, Survey Finds," published September 19, 2019, updated September 25, 2019, *New York Times*, www.nytimes.com/2019/09/19/arts/design/female-art-agency-partners-sothebys-artists-auction.html?smid=em-share.

"THOSE WHO WENT BEFORE": BLACK ART AT THE PENNSYLVANIA ACADEMY OF THE FINE ARTS

DANA E. BYRD

In 1900, the jury of the Pennsylvania Academy of the Fine Arts' Annual Exhibition bestowed the Walter Lippincott Prize for the best figurative painting to Philadelphia-born painter Henry Ossawa Tanner's *Nicodemus* and Harrison S. Morris, Managing Director of the Academy, purchased the painting for the collection (1899, pl. 46).[1] PAFA's acquisition was significant: the painting was the first artwork by an African American to enter the permanent collection. Tanner was from Philadelphia and had trained at PAFA academy under the realist painter Thomas Eakins (1896, pl. 19). However, concerned about his ability to thrive as an African American artist, including the ability to secure patronage and commissions in a country plagued by White visual, social, and legal discrimination against Black people, Tanner left his home and parents, Sarah Miller Tanner and African Methodist Episcopal Church Bishop Benjamin Tucker Tanner, for Paris (see pl. 18). Once in Paris, he trained at the Académie Julian. In Paris, Tanner achieved extraordinary success. He maintained a thriving painting practice while regularly exhibiting his dramatically lit and beautifully colored biblical genre scenes at different venues from Paris to Pittsburgh. Tanner lived in France for

Detail from Horace Pippin, *John Brown Going to His Hanging*, 1942 (pl. 51)

the remainder of his life. PAFA's first acquisition of a work of art by a Black painter was bittersweet for it was produced by a homegrown Philadelphia talent who was unable to find success in the United States.

Nicodemus is an excellent example of Tanner's formal and thematic concerns. The dramatic nocturne depicts a scene from the biblical Gospel of John in which the Pharisee and "ruler of the Jews" visits Jesus by night to receive his teachings. Befitting the night setting, Tanner made the skin of the savior, who had been traditionally depicted as a white man with fair skin, darker than other painted renderings by enveloping Christ in shadow. Tanner's painted signature, "H.O. Tanner, Jerusalem, 1899," infuses the painting with an air of authenticity. The artist had traversed the Holy Land, the region between the Jordan River and Mediterranean Sea sacred to all practitioners of the three Abrahamic religions, Islam, Christianity, and Judaism, during trips in 1897 and 1899.[2] *Nicodemus* was painted while the artist was at the place of what he believed to be Christ's ministry. Contemporary art critics, among them, Mariana Van Rensselaer, credited the artist's use of local models as part of the painting's appeal. More recently, art historians have argued for the significance of non-White models, and Tanner's provocative choice to darken Christ's skin, as a means of emphasizing Christ's universal appeal to all the world's people.[3] Tanner's representational decisions are intriguing because the artist had departed the United States, left his Black family, and a range of Black subject matter for Europe precisely because he sought a career unmarred by racism. Yet, his travels through the Holy Land seem to have given him the freedom to rethink the regimes of racial representation that had come to dominate Western art to great acclaim. PAFA's acquisition of *Nicodemus* is not only remarkable because it was the first artwork by a Black painter, but also because it celebrates an artist's depiction of non-White subjects.

Winslow Homer's painting *The Gulf Stream* (1899, fig. 1), featuring an African American subject, was also shown at PAFA's 1900 Annual Exhibition and greeted with a less than enthusiastic reception. Homer's painting depicts a Black man at sea aboard a dismasted boat in shark infested waters and owing in part to its centering of a heroic black subject, it was the subject of debate and discussion among attendees. Some viewers evinced a deep concern for the Black man and went so far as to contact Homer's dealer with questions about the man's fate. Homer, with his always wry sense of humor, responded to his dealer: "I regret very much that I have painted a picture that requires any description. . . . I have crossed the Gulf Stream *ten times* & I should know something about it. The boat & sharks are outside matters of very little consequence. *They have been blown out to sea by a hurricane.* You can tell these ladies that the unfortunate negro who now is so dazed & parboiled, will be rescued & returned to his friends and home, & ever after live happily."[4] In a stark contrast to these concerned reactions, a local art critic writing his own scathing review of the painting, reported that exhibition attendees laughed out loud at *The Gulf Stream*. He dismissed the seriousness of the

FIG. 1. Winslow Homer (American, 1836–1910), *The Gulf Stream*, 1899. Oil on canvas, 28⅛ × 49⅛ in. The Metropolitan Museum of Art, New York, Catharine Lorillard Wolfe Collection, Wolfe Fund, 1906, 06.1234.

scene as "a naked negro lying in a boat while a school of sharks [are] waltzing around him in the most ludicrous manner."[5] The ambivalent reception by the audience was surprising as the Philadelphia galleries had previously been the site of success for Homer. In 1893, PAFA was the first public institution to acquire one of Winslow Homer's paintings, the dramatic narrative landscape, *Fox Hunt* (1893, pl. 87), and had awarded the renowned painter the Academy Gold Medal in 1896. Prompted by these two episodes from PAFA's history—the first institutional acquisition of a painting by a non-White artist, and the ambivalent reception of Homer's painting of a Black man—this essay uses PAFA's collection to explore the intersection of Blackness, representation, and American art.[6]

PAFA's founding shareholders, among them the august painter Charles Willson Peale and sculptor William Rush, affixed their signatures to PAFA's charter application in 1805 with the intent of promoting "the cultivation of the FINE ARTS in the United States of America."[7] With its significant and historic art collections, long history of educating aspiring artists, and its central role as a venue and incubator for art, PAFA has been pivotal in fostering the growth of American art. From 1811 to 1969, PAFA's

Annual Exhibitions created opportunities for new and established artists to promote their artwork, while featuring some of the best in contemporary American art drawn from across the nation. Carefully curated exhibitions of artwork from the permanent collection have instructed and delighted generations of visitors and aspiring artists in matters of materials, technique, and style. The collection is also instructive in matters of race, specifically in its representations *of* Black people, and representations produced *by* Black people illustrate the centrality of Black people to American art production. From the mid-nineteenth century onwards, African American representation increased in prominence as the number of African American artists increased. In other words, being an American artist increasingly meant (with varying degrees of success) engaging the presence and history of Black people in this country.[8]

It is difficult to disentangle PAFA co-founder Charles Willson Peale's commitment to fostering American art from his complex involvement with the odious institution of slavery. Peale was the leading portraitist of the late eighteenth and early nineteenth centuries, painting luminaries and political figures central to the cause of American freedom. Of particular note is Peale's full-length portrait of George Washington, commissioned by the Supreme Executive Council of Pennsylvania to commemorate the Commander in Chief of the Continental Army's victories at the Battles of Princeton and Trenton, and the first official portrait of Washington (1779, pl. 1). Peale's subsequent depictions of other slave-owning men who ascended to the American presidency, including Thomas Jefferson and James Madison, are iconic and established a convention for picturing elected officials that endures to our own contemporary moment. It is unclear precisely when Peale first purchased and enslaved humans, however, the archival record suggests that when he moved from Maryland to Philadelphia with his family in 1775, he brought enslaved people, including a couple, Lucy and Scarborough, with him. He also hired enslaved workers when he required additional day laborers. Ironically, Peale served in the Pennsylvania militia during the Revolutionary War to advance the cause of freedom for colonists. He also voted for Pennsylvania's Act for the Gradual Abolition of Slavery while serving in the state assembly in 1780. This act provided for the gradual manumission of enslaved adult workers.[9] Accordingly, Peale manumitted Lucy and Scarborough, while keeping on Moses Williams, their son born in Philadelphia in 1777, as an indentured servant until he was twenty-eight years old. Peale, artist teacher and family patriarch, had named each of his children with his first wife, Rachel Brewer, after his favorite artists and befitting White children with artistic promise, he trained them in the fine arts of painting and drawing and other crafts. Likely believing that his race restricted his artistic potential, Peale limited the young Moses Williams's lessons to the crafts of taxidermy and silhouette-making.

In the 1790s, the entire Peale family, including Moses Williams, joined with the eldest Peale to create the Peale Museum. The museum, visible behind the curtain in Peale's self-portrait, *The Artist in His Museum* (1822, pl. 8) featured collections of

art, science, nature, and technology. It was a success, and the still-enslaved Moses Williams's silhouette-making stand was a popular attraction. Williams used a device, the physiognotrace, to quickly trace a profile of the sitter's face. The profiles were then cut and pasted onto a contrasting piece of paper. The artist's own silhouette portrait (an especially early example of a Black artist's self-portrait), inscribed with the title "Cutter of Profiles," announces Williams's role in silhouette-making and showcases Williams's accuracy and manual dexterity (fig. 2). Williams's facility with the machine ensured that he excelled at producing silhouette portraits. Indeed, the silhouette-making business was so profitable for Peale that he granted Williams his freedom one year in advance. Williams continued making silhouettes at Peale's Museum, and he was able to support his own family for many years. Peale, then, facilitated the development of one of America's earliest African American portrait artists. Yet, although Peale later repudiated slavery, he benefited in his career as an artist and in his everyday experience from labor extracted from enslaved people, making it difficult to separate his role as artist and co-founder of PAFA from his role as an enslaver.

In contrast to the intimate connection to slavery of one of PAFA's co-founders, early institutional acquisitions included artworks documenting the free African American presence in everyday life. German-born John Lewis Krimmel's 1812 genre scene, *Fourth of July in Centre Square* (pl. 64) records a lively midsummer celebration in front of a remarkable bit of Early Republic engineering, the Pump House. The Greek Revival domed structure housed twin pumps that drew clean water from the Schuylkill for distribution to public and private city buildings. In 1799, Benjamin Latrobe, architect and artist, had designed and supervised construction of the nation's first waterworks after the city had survived a yellow fever epidemic many believed was related to poor sanitary conditions. By coupling the depiction of the engineering marvel

FIG. 2. Raphaelle Peale (American, 1774–1825) and Moses Williams (American, 1777–1825), *Moses Williams, Cutter of Profiles*, c. 1803. White laid paper on black stock, 4 × 5 in. Library Company of Philadelphia, Print Department, Silhouette Collection [(3)5750.F.153b].

on the anniversary of the signing of the declaration of independence, Krimmel illustrates the city of Philadelphia's continued importance as a seat of economic and political power.

A cross-section of the city's residents mingle in the square. In the lower left foreground, an elderly woman serves alcoholic beverages to male celebrants; in the middle composition, the plain and dark clothing of a Quaker family contrasts with the fashionable dress of a group of residents; even more fashionably dressed White and Black residents perambulate around a circular fountain ornamented with PAFA co-founder William Rush's allegorical sculpture *Water Nymph and Bittern*. Children, emblems of the nation's bright future, appear throughout the composition.

The city was home to the largest free population of Black people in the United States at the time of the painting. Krimmel's inclusion of African American citizens reminds us that the Declaration of Independence's promise of equality for all did not yet apply to them. Decades later in 1859, Jacob C. White Jr., chairman of the Banneker Institute of Philadelphia, an all-Black literary society, acknowledged the fundamental contradiction of robust Black participation in Independence Day celebrations when many remained enslaved, and few were able to seize the full benefits of citizenship. During one such occasion in celebration of the republic's founding, White acknowledged these challenges even as he optimistically looked forward to celebrating the day when "in the full stature of men, we will stand up, and with our once cruel opponents and oppressors rejoice in the Declaration of our common country."[10] Krimmel's painting captured Black Philadelphians when they were not yet full inheritors of the republic's promises of equality, but one day soon they would be able to rejoice as full citizens.

Nearly a half century after Krimmel painted the July 4th scene, and in the same decade that John Henry Smythe became the first African American student to enroll in the Academy, John Quincy Adams Ward's plaster sculpture, *The Freedman*, of a Black man who has broken free of the shackles of enslavement and asserted his claim to equality, was exhibited at PAFA (1863, pl. 43). Ward's wartime interest in the subject matter likely stemmed from two events leading to the end of slavery in the United States, the daring acts of bravery undertaken by enslaved people who traveled to Union lines in acts of self-emancipation, followed by President Abraham Lincoln's Emancipation Proclamation, an 1862 executive order releasing enslaved people in Confederate-occupied states from slavery. With one half of a set of broken manacles dangling from his right hand, Ward's freedman has transitioned from his previous condition of servitude and become active in his own emancipation. Seated on a tree stump, with one leg extended and looking to the viewer's left, the now free man is in a liminal state, with the horror and indignities of enslavement relegated to the recent past and the promise of full citizenship to come. The sculpture was well-received in the North, with prominent art critic James Jackson Jarvis writing in 1863 that Ward's choice of subject, which

"tells in one word the whole sad story of slavery and the bright story of emancipation," had revitalized sculptural practice in the United States.[11]

Created two years into the Civil War, Ward's sculpture was timely, but also deeply steeped in modes of representation familiar to Western audiences. From the waist up, the rippling musculature of Ward's *Freedman* resembles the *Belvedere Torso*, a Roman marble sculpture of a nude male, dating to the 1st century BC. Two centuries after its excavation in the early fifteenth century, influential art historian Johann Joachim Winkelmann celebrated the *Torso* as a "deified form" that was the highest ideal of all ancient art.[12] The sculpture continued to serve as a model and venerated source of artistic inspiration for more than five centuries. The sculpture's influence persisted through the long nineteenth century as audiences who could not travel to Europe to see it encountered plaster copies and skillful print renderings in public collections in the United States, including PAFA. Budding artists at leading art institutes like PAFA engaged these copies as a mode of art instruction.[13] Ward's citation of the ancient sculptural torso, forged in the birthplace of democracy, in a celebration of Black emancipation in the United States underscores the significance of the ending of American slavery even as it confers importance on the Black subject. Thirty years before Winslow Homer featured the Black subject in oil paint on canvas, Ward's sculpted man elevated the formerly enslaved into a subject worthy of aesthetic representation. Ward's contemporary and symbolic representation of the African American freedom struggle enlivened the practice of American sculpture. The sculpture remained on view throughout the Civil War until 1866, nearly a year after the peace at Appomattox, before being accessioned into the institution's permanent collection. Ward's choice to cast the sculpture in bronze, likely the first bronze representation of a black man in American art, only heightened its power and immediacy.[14] Linking contemporary wartime developments to his sculpture, the artist added an inscription, "FORT WAGNER JULY 18th 1863" and "54th Mass.\ Colored Vols," commemorating the tragedy and triumph of the Massachusetts 54th Regiment's failed assault on the Confederate-held Battery Wagner, South Carolina. The all-Black regiment, led by Colonel Robert Gould Shaw, suffered heavy losses with nearly two hundred and eighty men of the six-hundred-man regiment killed in the battle. Crucially, their valor in the face of an almost certain defeat inspired Black men to join the Union ranks in large numbers, while demonstrating to everyday Americans that Black people were committed to the cause of their own liberation.

May Howard Jackson's bust *Slave Boy* (1899, pl. 47), takes up the representation of enslaved people forty years after the passage of the 13th amendment abolishing slavery and provides a powerful contrast to Ward's muscular representation.[15] The young artist was educated at the avant-garde Public Industrial Art School of Philadelphia, under the leadership of J. Liberty Tadd. The educational theorist Tadd promoted a model art education that was balanced between aesthetic and mechanical concerns. Jackson would have graduated from the school having studied "drawing, designing, free-hand drawing,

working design in monochrome, modeling, wood carving and the care and use of tools" and steeped in the "power of motivation" based on her individual interests.[16] Jackson brought that outlook to her studies at PAFA, where she earned a scholarship and enrolled as the first African American woman student.

Slave Boy was sculpted in 1899 during Jackson's last year at the Academy and decades after the end of slavery in the United States. In bronze mimicking melanin-rich flesh, the artist rendered an African American youth with an arched eyebrow who stares off into the distance engaged in thought. It is possible that Jackson used an unidentified male as a model, but this sculpture is not a portrait. Rather, as the title informs us, it is a depiction of an enslaved and racialized type, a long-standing subject of Western art. Introspective and resolute, Jackson's *Slave Boy* transports us in time and bring us face to face with history. The artist defies stereotype and in rendering the boy with a cognitive life and restrained emotion, re-presents history. In Jackson's conception of the slave past, enslavement was an imposed status, not a condition. The enslaved had been people capable of emotion, action, and like the Massachusetts 54th Regiment, even heroics.

Jackson continued to sculpt after she married and departed Philadelphia for Washington, DC, in 1902. In Washington, Jackson struggled to gain the recognition and financial success she hoped for as an artist. More than once, she was rejected from membership in artist's organizations because of her race. Jackson continued to make art, and eventually also taught in the Art Department at Howard University, a historically Black institution. Many of her distinguished subjects, including activist-philosopher W.E.B. Du Bois, educator Kelly Miller, and the poet Paul Lawrence Dunbar, were deeply involved in the New Negro Movement, an organized attempt to promote African American sociological issues within and outside of African American communities in the hopes of securing social and political equality. Reproductions of the sculptures were included in political rhetoric, philanthropy, and even cultural production as tools used to forward New Negro movement ideals. Jackson's sculptures of the movement's leading luminaries celebrated their efforts even as they continued their work. Her sculptural oeuvre might be understood as contributing to a new history of African America, one that acknowledges survival of an enslaved past through *Slave Boy* while celebrating new milestones through the portraits of New Negro leaders.

The New Negro movement's progressive ideology, emphasizing racial uplift for the "New Negro," inevitably raised the specter of the "Old Negro." A pair of portraits painted by PAFA-trained artist Laura Wheeler Waring embodies the different representational possibilities inspired by the movement. Waring, who was born into an upper middle-class family, was the third generation of her family to choose a teaching career. At the institution now known as Cheyney University, Waring directed the choir and taught art, even as she continued to paint and exhibit her own art. By the time that Waring painted *Anna Washington Derry* (c. 1927, fig. 3) she had been to Europe to take

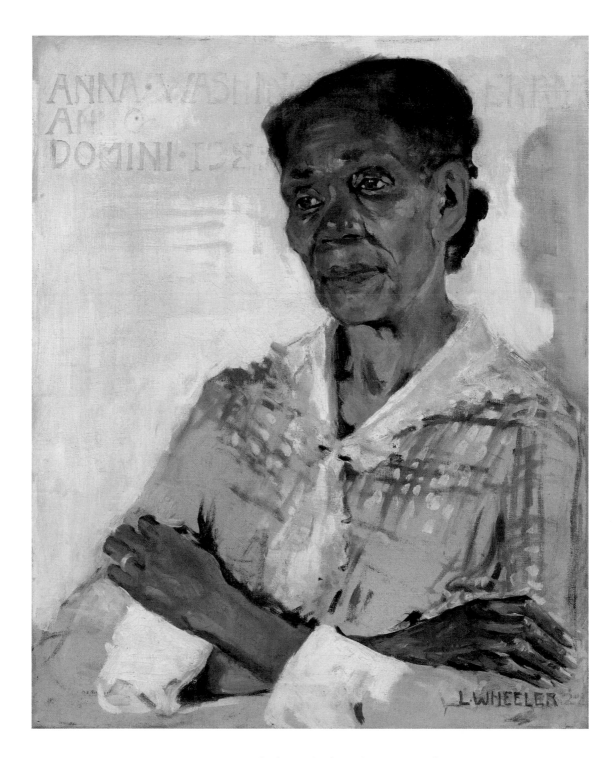

FIG. 3. Laura Wheeler Waring (American, 1887–1948),
Anna Washington Derry, 1927. Oil on canvas, 20 × 16 in.
Smithsonian American Art Museum, Gift of the Harmon Foundation, 1967.91.1.

art lessons twice.[17] She regularly contributed illustrations to *The Crisis*, an NAACP publication edited by W.E.B. Du Bois, and worked with publishers to provide book illustrations. She also painted portraits of socially prominent African Americans and of her own family members.

Waring's portrait *The Study of a Student* (c. 1940, pl. 29) is a lively, if casual, rendering of a young African American woman in profile who sits, hand supporting her head, elbow on a table, as she stares into the distance. Missing are the hallmark subdued palette, subtle gestures, and respectable surroundings of traditional portraiture (see pl. 15). From the triangular shape created by the head and torso of the sitter silhouetted against the spirited dusty pink background to the slate blue square of the table and the flower in the student's hair, this painting is a study in vibrant color and shape. Painted on a cardboard backed canvas, or "Academy" board, this painting is a study. Given Waring's commitment to portraiture, one imagines that the act of painting this picture allowed her to address different formal concerns: How does one render a portrait in three-quarter profile? When one paints a sitter whose face is turned, how much of their torso should face the viewer? Even as a study, a work in progress, this portrait had the power to counter the negative and stereotypical representations of African Americans so prevalent in mid-century American culture. In their place, Waring offers a positive and modern vision of a young African American woman.

In contrast to Waring's vision of the New Negro, her bust-length portrait *Anna Washington Derry* is emblematic of the artist's tremendous facility with paint. She rendered her subject's face in stunning detail, rendering her skin in a rich burnt umber tone, and highlighting her nose, cheekbones, and chin with olive flecks. The portrait is a study in contrasts, with Waring selectively deploying and withholding detail. Waring used impressionistic strokes of paint to enrobe the retired local laundress in a tan and olive plaid dress topped with an ivory kerchief. Derry embraces herself, crossing her arms and clasping her forearms as a gold ring gleams from her left hand. From the furrows in her brow, to the creased nasal labial folds and chin, her face is remarkably detailed. The flesh of just one of Derry's arms is painted in matte pigment, while the skin of the opposite arm appears well oiled; the harsh light entering the picture from the upper left casts a shadow on the pale yellow wall behind Derry doubling her. Finally, on the upper left canvas Waring has inscribed "ANNO DOMINI/ANNA WASHINGTON DERRY/192_" and signed her own name "L. WHEELER" on the canvas's lower left edge.

The circumstances that brought Derry to sit for Waring are mostly lost to history. Waring's portrait was not commissioned by Anna Washington Derry, rather Derry agreed to sit for Waring with the knowledge that the portrait was destined to be sold. Samuel and Minerva Derry, Derry's son and daughter-in-law, were Cheyney employees and Derry likely lived with them at the time that she sat for Waring. Did Waring find Derry to be visually striking? Was she interested in her connection to enslavement? After all, Derry was born in a slave state during the late 1850s, and even though she was

of roughly the same generation as Waring's parents, her life as a laborer, a member of the working class, meant that her life experience was quite different from that of Waring's upper middle-class parents.

Eager to exhibit these paintings, Waring applied for the New York–based Harmon Foundation's Fine Art award and included the portrait of Anna Washington Derry among the dozen paintings she submitted. The Harmon Foundation, a private philanthropic organization dedicated to supporting African American achievement in all areas, was the primary source of patronage for many artists working during the 1920s and 1930s. The Foundation recognized Waring's paintings, "with special mention of the picture marked: '61: Anna Washington Derry," with the First Award in Fine Art – William E. Harmon Foundation Award for Distinguished Achievement Among Negroes, a medal, and a $400 cash prize. One wonders what Waring felt about the judges' celebration of the Derry portrait, a working class outlier portrait in a group of portraits of leading African American luminaries. The Harmon Foundation later invited Waring to join Euro-American painter Betsy Graves Reyneau to create a group of portraits of accomplished African Americans. Waring's previous portraits prepared her for the project. In those portraits Waring made for the Harmon Foundation, we can glimpse traces of her earlier paintings, the angled shoulders of the student from the study portrait is echoed in Waring's gracious portrait of contralto Marian Anderson, and the crossed arms of Anna Washington Derry likely inspired composer Henry Thacker Burleigh's pose in his own portrait. More than twenty-thousand visitors saw the resulting exhibition, *Portraits of Outstanding Americans of Negro Origin*, in 1944 at its first venue at the Smithsonian Institution in Washington, DC. The exhibition traveled to different venues across the United States for a decade.

In 1940, Alain Locke, a professor at Howard University and leading theorist of the New Negro movement who published *The Negro in Art*, an influential book that argued Euro-American artists who were interested in Blackness and art produced by artists of the African diaspora comprised a category of art deserving of close study. Artists, collectors, scholars, and curators took this claim seriously; the Harmon Foundation's *Portraits of Outstanding Americans of Negro Origin* was just one of a dozen exhibitions of the late 1930s and 1940s prominently featuring art solely made by African Americans or art engaging African American themes. The others included *Contemporary Negro Art* (Baltimore Museum of Art, 1939) and *The Negro Comes of Age* (Albany Institute of Art, 1945). Art professor James V. Herring organized *The Negro in the American Scene* (Howard University, 1942), an exhibition devoted to paintings of African Americans by Euro-American artists. By relying on the exalted medium of painting, Herring's exhibition scheme allowed him to showcase the range of art production that encompassed representations of Black life. The earliest painting dated to 1761 and the most contemporary was made shortly before the exhibition opened. Herring identified paintings of Black life produced by nineteenth-century artists Winslow Homer and Thomas Eakins as

FIG. 4. Thomas Hart Benton (American, 1889–1975), *Aaron*, 1941.
Lithograph on off-white wove paper, 12¹³⁄₁₆ × 9½ in.
The Pennsylvania Academy of the Fine Arts, John S. Philips Fund Purchase, 1986.11.

capturing humanity and laying a critical foundation for twentieth-century depictions. Reginald Marsh (pl. 78) and Julius T. Bloch (pl. 31) were among the twentieth-century artists Herring singled out for praise for their willingness to experiment as they represented African Americans as individuals rather than types. For Herring, the paintings in *The Negro in the American Scene* documented the centrality to and importance of Black people in the nation's history even as they emphasized the talent and creativity of White American artists.[18]

By the 1930s, Missouri-born, Euro-American artist Thomas Hart Benton had cemented his reputation as one of the nation's best painters despite the drought of the Dust Bowl's endangerment of western agricultural production. Like Grant Wood, Benton was a regionalist, dedicated to representational paintings of rural folk culture. The artist was frequently tapped to create mural cycles featuring the nation's history, and he stubbornly refused to whitewash the nation's history. Instead, he insisted on representing uglier moments of the American past, including enslavement and post-Civil War white supremacist violence as unfortunate, but generative parts of midwestern history. Benton's portrait *Aaron* (1941, pl. 30) celebrates his subject's advanced age, emphasizing the elderly African American farmer's gray lambswool-like hair and burnished-bronze furrowed brow.[19] Weary, the man relies on a wooden rod to hold his body upright. His denim overalls and jacket are threadbare, revealing his strong work ethic, his clothing has worked as hard as he has. They are neatly patched; he cares for his things. We can imagine that his farmstead is carefully laid out, with a home and outbuildings surrounded by land made productive through labor, the furrows of the tilled ground undulating as far as the eye can see. Color, composition, and line, coupled with the elderly subject, allow him to celebrate the virtuous, hard-working salt of the earth farmers of the Midwest.

Benton's sitter was eighty-two-year-old Ben Nichols, who was born into slavery, and by titling the painting *Aaron*, the artist invokes Old Testament source material. According to the Book of Exodus, God appointed Aaron to serve alongside his younger brother, Moses. During the plague of Egypt that preceded the Exodus, Aaron's rod was endowed with miraculous power and, at its owner's command, could sprout flowers and bear fruit. Aaron assisted Moses in freeing the Israelites from bondage in a great exodus. In invoking Aaron in a painting of a formerly enslaved man, Benton likens the divine liberation of the Israelites to the end of enslavement for African Americans. Nichols's rod is at once support for an elderly man, and a promise of the return of fertile agricultural production for the Midwest. Making art accessible for middle-class collectors, Benton created an affordable limited series lithographic version of *Aaron* that sold for five dollars a print (fig. 4).

The Euro-American painter Julius T. Bloch, like Benton, was committed to noble painted representations of working class White and Black people. Bloch trained at PAFA and eventually served on the faculty there. Bloch's sensitivity may have been a

result of the financial hardships of his own family members, German Jews who emigrated to Philadelphia in 1893, which made him attentive to the emotional burdens of the Depression, its crushing effect on the morale of the average person. In circumstance and result, Bloch's portrait of his friend the artist Horace Pippin (pl. 31) embodies Bloch's approach to portraiture. Bloch and Pippin met during a visit to the home of sisters Rebecca Winsor Evans and Ellen Winsor, Pennsylvania art patrons. Bloch described his impressions of the artist: "He is full of life. . . . I am convinced that Pippin will go on creating more and more beautiful works, one feels that his whole mind, body, and soul are combining to bring about the fullest self-expression."[20] Bloch and Pippin quickly became friends. On one visit, Pippin gave the visiting Bloch a photograph of himself on the grounds of the Barnes Foundation by the photographer Carl Van Vechten. Two years later, Bloch reciprocated the gift with a painted portrait of Pippin based on the Van Vechten photograph. In classic fashion, Bloch captured the painter in profile without the patterned bark of the tree, instead silhouetting him against a greenish gray background. Pippin's striking profile and broad chest combine to create a noble and powerful portrait of the artist. Two years after that, Bloch attended Pippin's funeral and drew the artist in repose.

Bloch may have been "widely recognized for the intensity of his psychological character studies of the Negro," however, his interest in depicting African Americans was not always celebrated.[21] In 1934, Bloch was invited to submit a painting to a Center City department store for National Art Week. His entry, a portrait of Alonzo Jennings, a local Black man, was rejected, as the department store did not wish to "exhibit a portrait of a Negro in its windows" (fig. 5).[22] When asked if he could supply a portrait of a white man, Bloch demurred and refused to provide an alternative picture. Strikingly, the same picture had been included just a year before in The Museum of Modern Art's contemporary art exhibition *Painting and Sculpture from 16 American Cities* as one of four figurative works selected to represent the city of Philadelphia. The very different reception of the same painting, thirty years after PAFA's acquisition of *Nicodemus*, illustrates that beliefs about the value and importance of pictures of African Americans had slowly begun to shift.

Made during the height of the Black liberation movement and just seventy years after *Nicodemus* was added to the collection, two painting acquisitions, James Brantley's *Brother James* (1968, pl. 35) and Barkley L. Hendricks's *J. S. B. III* (1968, pl. 34), signal PAFA's full-throated commitment to educating and exhibiting art produced by Black people which continues today. Brantley and Hendricks were part of a larger contingent of Black artists, including Moe Brooker, who joined the Academy as students in the 1960s. Brantley's bold self-portrait occupies a liminal space between figurative and abstract painting. A mirror image of Rembrandt van Rijn's *Self-Portrait* (1659, National Gallery of Art, Washington, DC), the artist stands with one hand at his waist and faces to the right against a hazy golden background. Clad in a dark shirt, he is swathed below

FIG. 5. Photograph of the painting *Alonzo Jennings* by Julius T. Bloch (American, 1888–1966), 1934.
Black-and-white print (photograph), 10 × 8 in.
The Pennsylvania Academy of the Fine Arts Archives, PC0104_1934_016.

the waist in fabric rendered in a loosely painted pattern resembling the American flag. Brushstrokes delineate his features and soft curls of his afro even as loose expressive and shadowy brushstrokes threaten to engulf him in shadow. "Brother James" is at once a painter, an American, and part of a brotherhood of Black men. Famed American artist Andrew Wyeth was so taken with this self-portrait that in addition to awarding the painting first prize in a competition, he invited the young artist to his studio in Chadd's Ford, Pennsylvania, then a small rural community twenty-five miles from Philadelphia. Years later, Brantley reminisced over how meaningful his interactions with Wyeth were before acknowledging that "artists are direct beneficiaries of those who went before them and those who will come well after," a lineage that for Brantley included artists like May Howard Jackson, Laura Wheeler Waring, and Horace Pippin.[23]

A few months after his self-portrait earned a prize, Brantley sat for his friend and classmate Barkley L. Hendricks. Hendricks would become known for his distinctive life-size portraits of friends and family which revolutionized figurative painting by elevating everyday folks, Black and Latino people, into arresting portrayals of race pride and culture. Even as *J. S. B. III* participates in Hendricks's mode of representation, it holds special significance. Hendricks, after all, had been moved to paint his friend, a fellow Black artist, shortly after his subject had won acclaim for his own self-portrait. The resulting painting is certainly a response to Brantley's call for powerful representations of Blackness, but it also emphatically reminds us, as Tanner did in *Nicodemus,* that Blackness, and its representations, can be universally appealing and central to American Art.

PAFA has embraced this commitment and continues to build a collection representing the diversity of art produced by and of African Americans even as it educates the next generation of American artists.

1 *93rd Annual Report for the Pennsylvania Academy of the Fine Arts*, (Philadelphia, Pennsylvania Academy of the Fine Arts, 1900), 15, The Pennsylvania Academy of the Fine Arts' Archives; *94th Annual Report for the Pennsylvania Academy of the Fine Arts*, (Philadelphia, Pennsylvania Academy of the Fine Arts, 1900), 10, The Pennsylvania Academy of the Fine Arts' Archives.

2 For more on Tanner's Holy Land travels, see Anna O. Marley, "Introduction," in *Henry Ossawa Tanner: Modern Spirit,* ed. Anna O. Marley (Berkeley, CA: Pennsylvania Academy of the Fine Arts in association with University of California Press, 2012), 13–15.

3 Alan C. Braddock, "Painting the World's Christ: Tanner, Hybridity, and the Blood of the Holy Land," *Nineteenth-Century Art Worldwide* 3, no. 2 (Autumn 2004). http://www.19thc-artworldwide.org/autumn04/298-painting-the-worlds-christ-tanner-hybridity-and-the-blood-of-the-holy-land (accessed June 15, 2022).

4 Winslow Homer, Scarborough, Maine, letter to M. Knoedler & Co., New York, NY, February 19, 1902, see Artists' Letters and Manuscripts, Box 4, Folder 2, Crystal Bridges Museum of American Art, Bentonville, Arkansas.

5 Riter Fitzgerald as quoted in William Howe Downes, *The Life and Works of Winslow Homer* (New York: Houghton Mifflin, 1911), 135.

6 For more on the intersection of race and method in American Art, see Camara D. Holloway, "Critical Race Art History," *Art Journal* 75, no. 1 (2016), 89–92.

7 Articles of Association, Pennsylvania Academy of the Fine Arts, December 26, 1805. The Pennsylvania Academy of the Fine Arts' Archives.

8 For more on the impact of White supremacy and the production of art historical knowledge, see Gwendolyn DuBois Shaw, "The Decolonization of John Sloan," in "When and Where Does Colonial America End?," Colloquium, *Panorama: Journal of the Association of Historians of American Art* 7, no. 2 (Fall 2021). https://doi.org/10.24926/24716839.12714.

9 Gwendolyn DuBois Shaw, "'Moses Williams, Cutter of Profiles': Silhouettes and African American Identity in the Early Republic," *Proceedings of the American Philosophical Society* 49 (March 2005), 25.

10 Mr. Jacob C. White Jr., "Introductory Remarks," in *The Celebration of the Eighty-Third Anniversary of the Declaration of American Independence by the Banneker Institute . . . July 4, 1859* (Philadelphia: W.S. Young, 1859), 8.

11 James Jackson Jarves, *The Art-Idea* (New York, 1864; reprint, Cambridge, MS., 1960), 225–26 as cited in Kirk Savage, "Molding Emancipation: John Quincy Adams Ward's 'The Freedman' and the Meaning of the Civil War," *Art Institute of Chicago Museum Studies* 27, no. 1 (2001): 27. https://doi.org/10.2307/4102837.

12 Thomas Davidson, "Winckelmann's Description of the Torso of the Hercules of Belvedere in Rome," *The Journal of Speculative Philosophy* 2, no. 3 (1868): 187. http://www.jstor.org/stable/25665655.

13 Cheryl Leibold, "The Historic Cast Collection of the Pennsylvania Academy of the Fine Arts," *Antiques and Fine Art* (Spring 2010), 187–191.

14 Savage, "Molding Emancipation," 27.

15 Research on this recently acquired sculpture is ongoing, however, evidence suggests that PAFA's *Slave Boy* is a posthumous cast of the 1899 sculpture. See Swann Auction Galleries, *African American Art* Sale 2599 (New York: Swann Galleries, March 31, 2022), Lot 1.

16 J. Liberty Tadd, *New Methods in Education: Art, Real Manual Training, Nature Study; Explaining Processes Whereby Hand, Eye and Mind are Educated by Means that Conserve Vitality and Develop a Union of Thought and Action (1899)*, as cited in Lisa E. Farrington, "May Howard Jackson, Beaulah Ecton Woodard, and Selma Burke," in *Women Artists of the Harlem Renaissance*, ed. Amy Helene Kirschke (Jackson: University Press of Mississippi, 2014), 115.

17 For more on this work see Valerie Harris, "Life of a Portrait: Laura Wheeler Waring's Anna Washington Derry," *Pennsylvania Heritage Magazine* (Summer 2019). http://paheritage.wpengine.com/article/life-portrait-laura-wheeler-waring-anna-washington-derry.

18 James V. Herring, *The Negro in the American Scene* (Washington, DC: Howard University, 1942), 11.

19 Roger Medearis, "Student of Thomas Hart Benton," *Smithsonian Studies in American Art* 4, no. 3/4 (1990): 47–61. http://www.jstor.org/stable/3109015.

20 Anne Monahan, *Horace Pippin, American Modern* (New Haven: Yale University Press, 2020), 182.

21 Milton M. James, "The Negro Paintings of Julius Bloch," *Negro History Bulletin* 20, no. 3 (December 1956), 51.

22 Margaret Eisen, "Julius Bloch: The Time Has Come," *Pennsylvania Heritage Magazine* (Summer 1989). http://Paheritage.wpengine.com/article/julius-bloch-time-has-come.

23 Susanna W. Gold and Rachel McCay, "A Conversation with James Brantley," in *We Speak: Black Artists in Philadelphia, 1920s–1970s*, ed. William Valerio (Philadelphia: Woodmere Art Museum, 2018), 50.

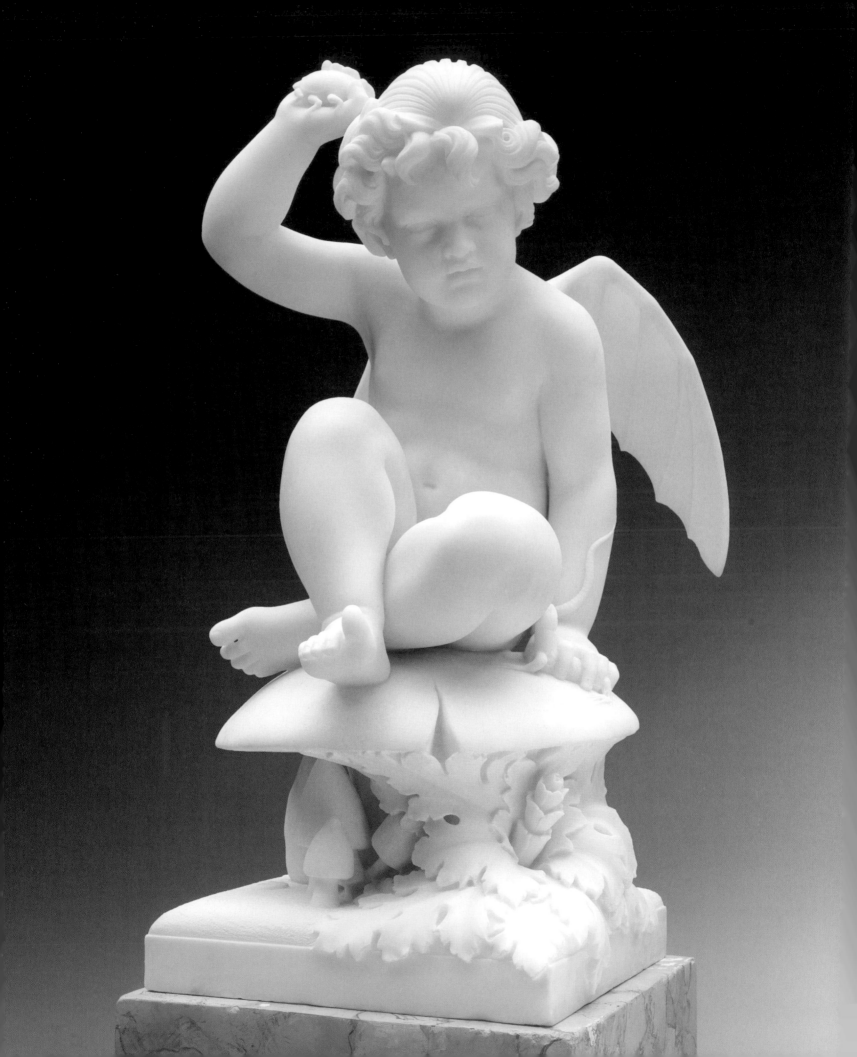

HOMOSEXUAL ART BEFORE HOMOSEXUALS

JONATHAN D. KATZ

It is admittedly counterintuitive to argue that Harriet Hosmer's marble sculpture *Puck* (1856, pl. 11) is a signature work of nineteenth century queer art, as it does not appear to accord in any way with our current understanding of the representation of same-sex desire. True, there is no real doubt that Hosmer was attracted to her own sex and cavorted openly in Rome with the equally celebrated American actress Charlotte Cushman, famous for portraying men in so-called trouser or breeches roles (fig. 1).[1] But the sculpture of a small, winged fairy sitting on a toadstool hardly conjures images of queerness in any form we possibly recognize—and that is exactly the point. To sift the past with a presentist arrogance is to assume that we can know what historical forms of sexual difference looked like, to assume that distant worlds thought like us and operated out of our familiar representational frame—a notion that is verifiably false. Nor is it sufficient to claim that because Hosmer was likely what today we would call a lesbian, any work of art she made was somehow inherently queer. Hosmer, as arguably the leading neoclassical American female sculptor of her period, completed many works that, far from being dissident, reproduced some of the most orthodox, stereotypical

FIG. 1. Charles D. Fredericks & Co (1823–1894), Charlotte Cushman in costume as Romeo, 1850–1859. Carte de visit. Billy Rose Theatre Division, The New York Public Library, New York Public Library Digital Collections.

forms and themes then governing sculpture, especially codes for the representation of women's bodies, resulting in white marble busty busts that shamelessly catered to the heterosexual male gaze.

At the same time, it is not irrelevant to the claims I am making that Hosmer was not only close with Cushman, but was described in an 1867 newspaper article, along with Cushman, as cutting a distinctly masculine figure: "Each of these ladies has a strong and tireless energy, and a muscular physique which many men may well envy."[2] Here, as throughout the article, the prospect of these two famous women together in Rome not only elicits no uneasiness on the part of the article's unnamed author, but furthermore permits a colorfully positive description of their aggressively athletic, masculinized, even butch lifestyle. They are as warmly appraised for their gender non-conformity as they are for their generosity and unstinting support of other expats. In short, their decided difference from most other women at this time elicits nothing but an affirming review—clear evidence that the darkening clouds of homophobia had not yet coalesced in this period before same-sex attraction earned a name and became a typology. After all, before 1869, homosexuals did not exist, only homosexual acts. Same-sex inclination did not generate a formal identity category until 1869—more than a decade after Hosmer's c. 1856 sculpture—when the Hungarian writer and activist Karl Maria Kertbeny coined the term "homosexual." Thus the question that animates the bulk of this essay: what did a homosexual art look like before the very word homosexual existed? Since the term was not even translated into English until 1892, and was not widely used in America outside of a specialist juridical-medical context until the 1930s, "homosexuality" is only roughly as old as the oldest living Americans today.[3]

Hosmer's *Puck* was one of her most successful inventions, with copies made by studio assistants and sold around the world. It also constitutes a telling case study in the development of queer art from the period before the words we now use to describe

same-sex desire had yet to appear. Puck was a familiar figure in British popular culture, cast as a trickster, fairy, or hobgoblin and likely dating from the Middle Ages.[4] Famously made the key protagonist in William Shakespeare's *Midsummer Night's Dream*, Puck was most traditionally a house spirit, associated either with the completion or the disruption of household chores.[5] Although today generally figured as male because of Shakespeare's use of the masculine pronoun, Puck was traditionally not gendered. As Shakespeare's text underscores, Puck, befitting a trickster figure, can be both a helpmate or a hindrance, depending on whether the bribe offered is deemed sufficient. So Puck is a gender non-binary or even male figure associated with the feminine-coded chore of housekeeping, who, whether good or naughty, is nonetheless clearly an unsettling force. Onto these already ample grounds for the figuration of sex/gender dissidence in the mid-nineteenth century, we can add that in the decorous environs of neoclassical sculpture—with its reverence for history and elevated subject matter—Puck clearly represents an eruption of something uncontained and disruptive. Here Puck is depicted as an ungendered, petulant child, one hand upraised as if about to throw a corpulent insect, sitting on poisonous toadstools. With wings more bat than bird, and a suggestively upraised big toe, Puck is the nexus of a range of discomfiting, if not actively dangerous, nineteenth-century natural archetypes, from nocturnal vampires to lethal toadstools to sexualized, spiteful children.

In a cultural context that lacked the prospect of naming and framing herself, Hosmer chose a subject and represented Puck in a way that analogized social dissidence, gender-queerness, and a performative refusal of accepted norms of gender and class comportment. Today, of course, we register very little of the pointed nonconformity that this sculpture embodied when it was made, but the task of a queer art history is to uncover how, in the absence of the very language we use to describe sexuality—indeed, in the absence of the notion of sexuality itself as an essentialized and discreet aspect of human identity—we can nonetheless uncover a queer history before it was even conceptualized and named.

Paradoxically, the rise of an LGBTQ+ liberation movement in the late 1950s and early 1960s actually spelled the end of a flourishing queer culture in America. True, that culture thrived in the shadows, was always vulnerable to both individual and state-sanctioned violence, and could rarely articulate itself openly. Its fate was decidedly up and down, and not many, in short, would want to return there. But the virtual ban on naming itself also conferred certain advantages too little acknowledged, chiefly opening a free passageway between different sex and same-sex sexuality that, at times, came to more resemble a teeming overpass than a narrow footbridge. In a culture that heavily sanctioned pre- or non-marital sexuality, men could and did have sex with other men, and women with other women, in a way that evaded social inscription. Crucially, the defining taxonomies of the time emphasized verbs over nouns, or sexual acts over sexual identities, such that intimate relations with a member of one's own

sex was not necessarily even proscribed, as long as one adhered to the norms of one's gender, namely as the active partner for men and the passive one for women.

But, and this was critical, same-sex sexuality mostly worked very hard to dissociate itself from any label or category—that is, outside the in-group of lovers and intimates who could freely name themselves. Labeling its own existence was, in fact, its chief taboo, since naming inevitably brought up various forms of policing. The trick was to chart that vast gulf between knowledge and acknowledgement, between knowing and saying, and in the nineteenth century, we will find, that was an expanse that stretched from the Atlantic to the Pacific oceans.

The visual arts were the medium that offered the greatest range of possibilities for figuring the gulf between knowing and saying, for they were uniquely suited to evoking the self-evident but unspoken. That visual representation did not require the use of naming words was of course critical, but so too was the prospect of creating such richness and fullness in the visual scene that the viewer could quite literally see what they wanted to see. That is a quality of surpassing strength in the arts, the ability to speak to multiple audiences with radically different competencies at once. No wonder, then, that the visual arts are the largest extant archive of queer historical evidence dating from before the rise of the modern liberation movement.

Even long after the homosexual came into being, same-sex acts did not necessarily mark one as queer. People engaged in same-sex sexuality for a wide variety of reasons, and being homosexual was only a part of that: it could be out of desire, or for release, or for material benefits, sometimes it was out of loneliness, and other times out of love, sometimes it was even an act of power or violence— in short, it was just like heterosexuality. Only some of these reasons would eventually earn the sobriquet "homosexual." So a queer art history must include artists who were themselves not necessarily queer, since desire was then much more fluid, and less specified.

Frank Duveneck's 1876 *The Turkish Page* (pl. 45) is an excellent example of a queer painting by an artist who was in all likelihood not queer. A bravura display of brushwork by an artist less than a decade out of art school, it falls squarely into the then-popular Orientalist genre, which tended to displace Euro-American erotic fantasies onto a mythic Near East. Duveneck's image hits all the familiar Orientalist notes, from the exoticism of the cockatoo to the bare chested, languorous boy covered in a velvet skirt, to the leopard skin rug. That the boy is a page, in a distinctly inferior position to an older master, is as central as is the fact that he is Turkish. At the time the painting was made, the Ottoman empire was undergoing a protracted, slow decline. No longer able to compete with Western Empires—the year the painting was completed, the Ottomans lost a war with Russia—the Turk became in the West the figure for a decadent, self-satisfied, feminized, and passive East in stark contrast to a more vigorous, manly, colonizing West. In short, this was an ideologically loaded image meant to flatter its American viewers at the expense of the Turks.

FIG. 2. Jean-Léon Gérôme (French, 1824–1904), *Snake Charmer*, c. 1879. Oil on canvas, 32⅜ × 47⅝ in. The Clark Art Institute, acquired by Sterling and Francine Clark, 1942, 1955.51.

Importantly, it is also an instance of the political utility of homophobia from a period in which the word "homosexual" had yet to be translated into English. The Ottoman Turks were widely thought to prize male beauty above female, and a recurrent European Orientalist trope was that the Turks, especially, enjoyed sex with boys—as long as they were the active partner—evidence of the limitations of an act-based model of sexual norms.[6] This painting's passively sprawled out boy suggests a less salacious variation on the theme subsequently made famous in Jean-Léon Gérôme's celebrated *Snake Charmer*, painted three years later, where a nude boy is handling a large snake while a group of tribal elders stare not at the massive snake but at the young boy's naked manhood (fig. 2). But Duveneck's boy is even younger, amplifying its political charge, for these Orientalist narratives of boy-loving Turks were inseparable from an increasingly militant Western colonizing drive that saw the Ottoman Empire as weak, unmanly, and unnaturally pleasure seeking, thus making its territories ripe for plunder.

In contrast to Duveneck's loaded ideology in *The Turkish Page* is Thomas Eakins's warm and lively portrait of his friend, the poet Walt Whitman (1887–88, pl. 16). An unusually informal, even casual image by an artist known for his many rigorous studies of his subjects, Eakins's portrait captures the Whitman that Whitman himself

FIG. 3. Thomas Eakins (American, 1844–1916), *Swimming*, 1885. Oil on canvas, 27⅜ × 36⅜ in. Amon Carter Museum of American Art, 1990.19.1.

FIG. 4. Circle of Eakins, Thomas Eakins and students, swimming nude, c. 1883. Platinum print, 8¹⁵⁄₁₆ × 11¹⁄₁₆ in. Pennsylvania Academy of the Fine Arts, Charles Bregler's Thomas Eakins Collection, purchased with the partial support of the Pew Memorial Trust, 1985.68.2.480.

propounded, the kindly, jovial, warm-hearted American who sympathized with all humanity, whatever their social station. Eakins and Whitman were so close that Eakins's long-time assistant and friend (and possible erotic fixation) Samuel Murray served as a pallbearer at the poet's funeral.[7] Indeed, Eakins was contacted immediately after Whitman's death, and he and Murray completed the poet's death mask.

Whitman and Eakins shared an interest in the nude, especially the male nude, and consequently, both suffered forms of censorship and attacks on their presumptive moral fiber. Indeed, at the Pennsylvania Academy of the Fine Arts (PAFA), Eakins introduced life drawing from the nude for the first time in an American art school, as instruction previously used only plaster casts. Whitman had to tone down the all-but-explicit homoeroticism of his great *Leaves of Grass* (1855) in its subsequent editions, and Eakins's *Swimming* was politely refused by the man who commissioned it—as a birthday present for his wife (1855, fig. 3). But when, in 1886, Eakins removed the loin cloth covering a male model to explain finer points of anatomy to a women's drawing class, PAFA felt it had to let him go. Not unlike Hosmer's irruptive figure of Puck, both Whitman and Eakins's bold, even willful inappropriateness, their lack of attention to dominant social mores, constituted the terms of their sexual difference. In short, it was their collective refusal of heteronormative social codes that marked them as queer, a queerness defined less in terms of what they did than how they positioned themselves in society.[8]

But in this era of homosexuality before homosexuals, if a dissident ideology is the chief quality of queerness, what happens to the body? Whitman was exemplary in creating a space for embodiment, while mapping a territory that never actually named what it nonetheless described. For example, he opened section V of "Song of Myself" with these words:

I believe in you my soul, the other I am must not abase itself to you,
And you must not be abased to the other.
Loafe with me on the grass, loose the stop from your throat,
Not words, not music or rhyme I want, not custom or lecture, not even the best,
Only the lull I like, the hum of your valvèd voice.
I mind how once we lay such a transparent summer morning,
How you settled your head athwart my hips and gently turn'd over upon me,
And parted the shirt from my bosom-bone, and plunged your tongue to my
bare-stript heart,
And reach'd till you felt my beard, and reach'd till you held my feet.[9]

The poem describes the relationship of the soul to "the other I am," namely the body. But that relation does not end, as poetry usually did, with the triumph of the soul over the body, but quite the converse. For here Whitman describes the relationship between his body and soul as a coupling, a specific erotic act in which "your head athwart my

hips," you "gently turn'd over upon me" and, thus poised between beard and feet, "you" (which is of course also me) find validation, unusually for a poet, neither through words nor music, but merely through "the hum of your valvèd voice." What is being described, in short, is the soul performing fellatio on the body, as if to suggest that in the context of the relation of soul to body, the soul can only express itself in and through the body, as that which animates the body—indeed, that the soul is the body and the body the soul, locked forever in an amorous embrace. But this is queerness at such a level of abstraction and generalization as to successfully evade detection as queer until only recently. The same is true of Eakins, whose photographs of his own students marry an exploration of form with profound desire, such that what today we would call sexuality moves in and out of visibility, becoming in the end what they were ostensibly at the outset, figural studies (fig. 4). In both Whitman and Eakins, in short, desire cannot be understood separately from form, for form assumes its peculiar contour only in and through the pressure of desire.

Winslow Homer offers a still different framing of the workings of non-normative desire, evident in the consistent refusal to countenance male/female social interaction in any of his works. Look at almost any work by Homer, and you'll see that men and women may share the same space, but as if each lives in their own sex-segregated world. Women gather, awaiting men returning from the sea, or enjoy themselves without men on the beach, while the men go out to sea only with other men. This sex-segregation was of course a much more standard form of social organization in the nineteenth century than today, but Homer takes it to extremes, as if he is almost incapable of imagining women and men together in any normal interactions. Indeed, the only images of sensual abandon, and not incidentally, bare flesh, in all of Homer's work, take place in the scenes set in the Caribbean, among Black figures, as if the only way to imagine desire was to place it at the margins of his sense of America, both geographically, racially, and other-wise. But even here, Homer cannot stop a moralizing voice from intervening and so in his magisterial *The Gulf Stream*, he sets a handsome, bare-chested Black man alone in a small boat against an overdetermined executioner's gallery of lethal dangers, ranging from prowling sharks to a broken mast, furious waves, that tiny boat, and a violent squall on the horizon, complete with a twisting waterspout, as the languid protagonist, in an odalisque pose, makes no effort to hail the passing ship that surely will never rescue him (see Byrd, fig. 1). There are, in short, a laundry list of dangers between the painter and this curiously unruffled male figure in that bobbing boat.[10]

So when we look at a work such as Homer's great *Fox Hunt* (1893, pl. 87), the artist's familiar gender dimorphism and animating sense of danger around difference is now displaced onto the anxious interaction of two very different species. A lone, hungry fox is looking to raid a crow's nest, as the pair-bonded crow parents dive-bomb the preda-tor. Here again, sexuality is not represented in any legible way—neither in terms of the representation, nor in terms of the irruption of the inassimilable—but that does not

mean that it is completely absent either. The figure of a lone and lonely fox seeking to challenge a united pair bond offers up a period allegory of sexual difference, and its inherent segregation, isolating loneliness, and potential for violence, that may very well have resonated with a man who elected to live alone in Prouts Neck, Maine, even after his great success in the metropolitan art markets.

Marsden Hartley's jaunty, semi-figural *Flower Abstraction* from 1914 (pl. 60) emblematizes the artist's very different approach to representing the unrepresentable. He evolved a highly developed, completely private symbology of queer representation that could function in so clandestine and personal a manner as to be virtually illegible, while at the same time being fully public. *Flower Abstraction* is formally kin to his great *German Officer* series, and cites enough of its codes as to prove vaguely decipherable as more than a mere flower painting. The German officer series was developed after Hartley fell in love with a young German officer named Karl von Freyberg, who was killed in the early days of World War I. Unable to openly express his grief over the death of a man who would soon be classed as his national enemy, Hartley evolved his personal symbology which resembled nothing so much as pure abstraction. Deeply Catholic, the paintings imagined the young man's ascent into heaven with willfully crude abstractions of religious iconographies such as haloes or the almond-shaped oval that surrounded the Virgin Mary called a mandorla (fig. 5). The "flower" assumes a human-like form, with arms akimbo, situated above a striped banner that in the *German Officer* paintings resembles a German Naval flag, but here assumes the form of the Belgian flag, with its vertical red, yellow, and black stripes now made horizontal. Before World War I, Belgium was a neutral country, but the Germans, seeking to attack France from an unsecured border, invaded Belgium, thereby violating Belgian neutrality and thus drawing England into the war. Von Freyburg, having led a platoon through Belgium, was killed by the British at the Battle of Arras in France, thus bringing Belgium into play as the proximate cause of his death. The golden halo around his head, the mandorla-shaped concentric stripes, and the radiating rays next to a sun-like form, all bespeak the painter's hope-filled imagining of von Freyburg being assumed, like the Virgin, into heaven.

Georgia O'Keeffe's *Red Canna* (1923, pl. 61) offers yet another object lesson in the queerness of paintings that do not look queer. O'Keeffe, celebrated as the premier "woman" painter of her era, had long been subjected to a baying, unrestrained sexism in the criticism of her work, a chorus often led by the men closest to her, who saw her work as a tribute to their masculine prowess. No less intimate a critic than the man who would become her husband, the art dealer, writer, publisher, and photographer Alfred Stieglitz wrote of her in 1919, four years before their marriage, "Woman feels the world differently than Man feels it. . . . The Woman receives the world through her Womb. That is the seat of her deepest feeling. Mind comes *second*."[11] Beginning the year he wrote this, Stieglitz also began to photograph O'Keeffe, eventually producing 331 photos of her

FIG. 5. Marsden Hartley (American, 1877–1943), *Portrait of a German Officer*, 1914.
Oil on canvas, 68¼ × 41⅜ in. The Metropolitan Museum of Art, New York,
Alfred Stieglitz Collection, 1949, 49.70.42.

into the 1930s, images that were strikingly intimate and notably explicit for their day. Not surprisingly, between his photos and his writing, O'Keeffe, significantly younger, was publicly cast as *his* muse, and her flower paintings such as *Red Canna* widely framed not only as emblematically female, but as a woman's tribute to a man's virility.

Despite the obvious labial quality of works like *Red Canna*, with their implicit penetrability and erotic coloration, O'Keeffe, resisting this male appropriation of her work, steadfastly argued that her flower paintings were not analogs of female genitalia. In 1939, as she wrote in *About Myself* for her exhibition at An American Place Gallery:

> A flower is relatively small. Everyone has many associations with a flower--the
> idea of flowers. . . . Still - in a way - nobody sees
> a flower - really - it is so small - we haven't time - and to see takes
> time like to have a friend takes time . . .
> So I said to myself - I'll paint what I see - what the flower is to me but
> I'll paint it big and they will be surprised into taking time to look at it . . .
> Well - I made you take time to look at what I saw and when you took
> time to really notice my flower you hung all your own associations with
> flowers on my flower and you write about my flower as if I think and see
> what you think and see of the flower - and I don't . . .
> I have wanted to paint the desert and I haven't known how. . . .
> So I brought home the bleached bones as my symbols of the desert. To me they
> are as beautiful as anything I know. To me they are strangely more living than the
> animals walking around - hair, eyes and all with their tails switching. . . .[12]

But as O'Keeffe switched to her now famous desert bones themes, what has not been noticed is how in works such as her *Summer Days* from 1936, the eccentric arrangement of the bones continues to suggest a female reproductive tract, albeit now in terms no longer inviting in male erotic terms (fig. 6). Dry and hard, this is now *vagina dentata*— but as she notes, "To me they are strangely more living than the animals walking around." This deliberate personal encoding of her own embodiment, with a flower now strategically placed below the skull's opening, suggests a high degree of self-consciousness and a willful attempt to continue to represent the female body in a way she calculated was illegible to a majority audience, while at the same time, allowing it to continue to carry her private significances. While O'Keeffe likely had a few female lovers, she was primarily heterosexual. Yet she is queer in the sense in which I have been developing it in this era before queer liberation, causing her work to carry personal, private, even erotic meanings at odds with dominant culture, even as it was embraced by that culture.

The desert paintings' highly self-conscious, very particular illegibility is in a sense not that far from Hosmer's *Puck*, Eakins's *Whitman*, Homer's *Fox Hunt,* or Hartley's *Flower Abstraction*. They are all a queer kind of paradox—public images of private

FIG. 6. Georgia O'Keeffe (American, 1887–1986), *Summer Days*, 1936.
Oil on canvas, 36⅛ × 30⅛ in. Whitney Museum of American Art, New York,
Gift of Calvin Klein, 94.171.

significance. American art has long been powered by the medium's unparalleled ability to address multiple audiences with differing capacities and interests, each according to their own competency, speaking quite articulately out of both sides of its mouth at the same time. Far from being marginal, queer artists not only helped define the canon of American art, at PAFA and beyond, but they also represented America to itself, even in that period of homosexuality before homosexuals.

1 Cushman was famous for her so-called breeches roles, performing as a man. In "Miss Cushman and Mr. Forrest," in *Gleason's Pictorial Drawing-Room Companion* (Boston) 1, no. 31, November 29, 1851, Cushman is favorably compared to Edwin Forrest, then considered the epitome of masculinity on the American stage, "[Charlotte Cushman's] singularly masculine voice, and fine conception of the part [of Romeo], enable her to do it far more than the common degree of justice that the character usually receives from reputable male performers. We are no advocates of this assuming male characters by females, but in this instance partial success has crowned the effort."

2 "Rome Gossip," *Daily Ohio Statesman*, March 15, 1867, 1 (apparently originally published in the *Boston Post*); for more on Hosmer in Rome, see Martha Vicinus, "Laocooning in Rome: Harriet Hosmer and Romantic Friendship," in *Women's Writing* 10, no. 2 (2003): 353–66.

3 The first known appearance of the word *homosexual* in English is thought to have been in the context of Charles Gilbert Chaddock's 1892 translation of Richard von Krafft-Ebing's *Psychopathia Sexualis*, a widely read account of various sexual practices that classed anything but heterosexual monogamous sex directed towards procreation as a perversion. On the terminology used for same-sex relationships before the 1930s, see George Chauncey, "Christian Brotherhood or Sexual Perversion? Homosexual Identities and the Construction of Social Boundaries in the World War I Era," in *Hidden From History: Reclaiming the Gay and Lesbian Past*, Martin Duberman, Martha Vicinus, and George Chauncey eds., (New York: New American Library, 1989), 294–317.

4 See Anne E. Duggan, Donald Haase, and Helen J. Callow, eds., *Folktales and Fairy Tales: Traditions and Texts from around the World* (Santa Barbara, CA: Greenwood, 2016), P-Z,: 825–26. Significantly, Hosmer's 1856 sculpture antedates the founding of *Puck*, a popular American humor magazine, which, reversing the term's trajectory, spun off a British version.

5 Shakespeare's verse, deploying Puck's other common name, Robin Goodfellow, is emblematic in this regard: "that shrewd and knavish sprite / Call'd Robin Goodfellow: are not you he/ That frights the maidens of the villagery; Skim milk, and sometimes labour in the quern/ And bootless make the breathless housewife churn;/ Mislead night-wanderers, laughing at their harm? / Those that Hobgoblin call you and sweet Puck, / You do their work, and they shall have good luck: /Are not you he?"

6 See Joseph Boone, *The Homoerotics of Orientalism* (New York: Columbia University Press, 2014).

7 The exact nature of their relationship is still a contentious subject, but they shared a studio and spent a great deal of time together. Eakins photographed Murray in the nude and painted him and conversely, Murray sculpted Eakins at least three times.

8 See Jennifer Doyle, "Sex, Scandal, and Thomas Eakins's The Gross Clinic," *Representations* 68 (Autumn 1999), included in *Sex Objects: Art and the Dialectic of Desire* (Minneapolis: University of Minnesota Press, 2006), 1–33.

9 Walt Whitman, "Song of Myself," Section V in *Leaves of Grass*.

10 See Christopher Reed's early explication of the homoerotic Homer in "The Artist and the Other: The Work of Winslow Homer," *Yale University Art Bulletin* 40 (Spring 1989): 69–79.

11 Alfred Stieglitz, "Woman in Art," from an October 9, 1919, letter to Stanton Macdonald-Wright, quoted in Dorothy Norman, *Alfred Stieglitz: An American Seer* (Millerton, NY: Aperture, 1973), 137.

12 Georgia O'Keeffe, in *Georgia O'Keeffe: An Exhibition of Oils and Pastels*. An American Place Gallery, New York, January 22–March 17, 1939. The essay is reproduced here: https://www.okeeffemuseum.org/wp-content/uploads/2015/03/taketimetolooksource.pdf.

PORTRAITURE

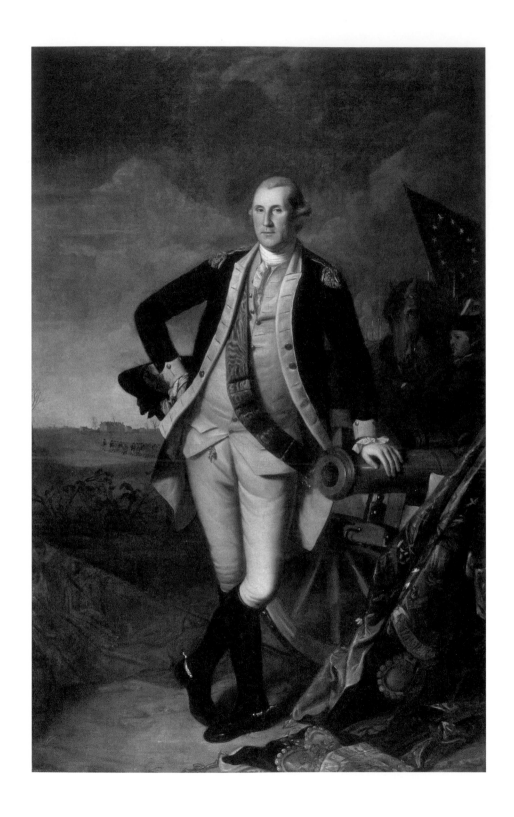

1 Charles Willson Peale (American, 1741–1827)
George Washington at Princeton, 1779
Oil on canvas, 93 × 58½ in.
Gift of Maria McKean Allen and Phebe Warren Downes
through the bequest of their mother, Elizabeth Wharton McKean, 1943.16.2

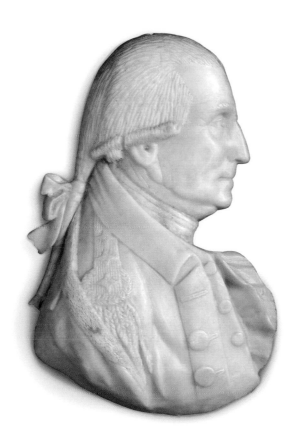

2 Attributed to Patience Lovell Wright (American, 1725–1786)
 Profile Portrait of George Washington, c. 1784–86
 Wax relief, 9½ × 6¼ in.
 Museum Purchase, 2019.46

3 James Peale (American, 1749–1831)
 The Artist and His Family, 1795
 Oil on canvas, 31¼ × 32¾ in.
 Gift of John Frederick Lewis, 1922.1.1

4 Gilbert Stuart (American, 1755–1828)
 George Washington (The Lansdowne Portrait), 1796
 Oil on canvas, 96 × 60 in.
 The Pennsylvania Academy of the Fine Arts, Bequest of William Bingham, 1811.2

5 Attributed to Joshua Johnson (American, active 1796–1824)
 Unidentified Woman, c. 1810
 Oil on canvas, 30½ × 24 in.
 Gift of Mrs. Edgar L. Smith, 1980.5.1

6 Attributed to Joshua Johnson (American, active 1796–1824)
Unidentified Man, c. 1810
Oil on canvas, 26⅛ × 22 1/16 in.
Gift of Mrs. Edgar L. Smith, 1980.5.2

7 Sarah Miriam Peale (American, 1800–1885)
 Anna Maria Smyth, 1821
 Oil on canvas, 35¹⁵⁄₁₆ × 27⁷⁄₁₆ in.
 Gift of Mrs. John Frederick Lewis (The John Frederick Lewis Memorial Collection), 1933.10.67

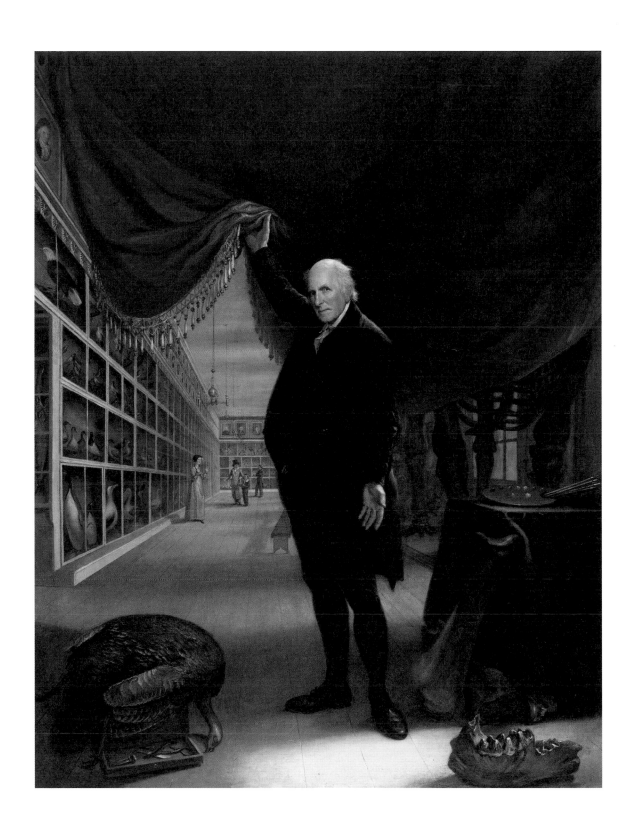

8 Charles Willson Peale (American, 1741–1827)
The Artist in His Museum, 1822
Oil on canvas, 103¾ × 79⅞ in.
Gift of Mrs. Sarah Harrison (The Joseph Harrison, Jr. Collection), 1878.1.2

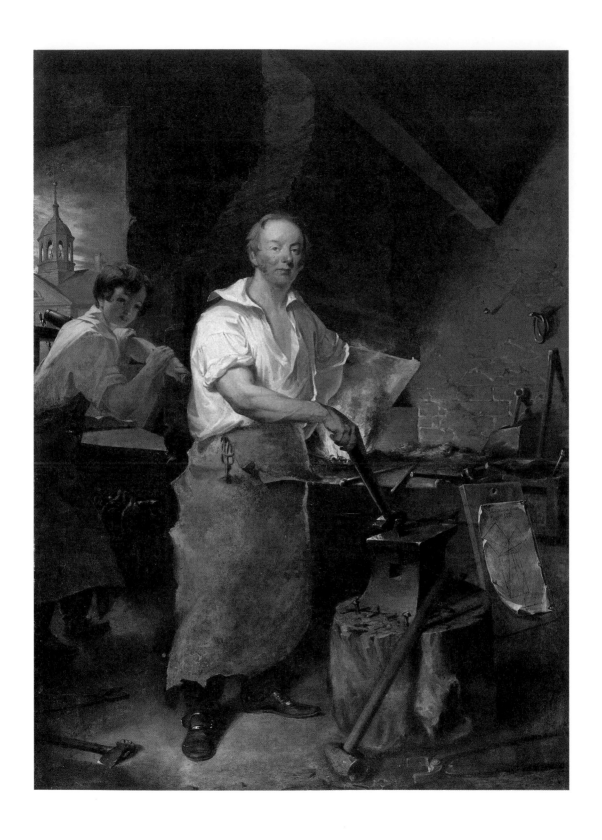

9 John Neagle (American, 1796–1865)
Pat Lyon at the Forge, 1829
Oil on canvas, 94½ × 68½ in.
Gift of the Lyon Family, 1842.1

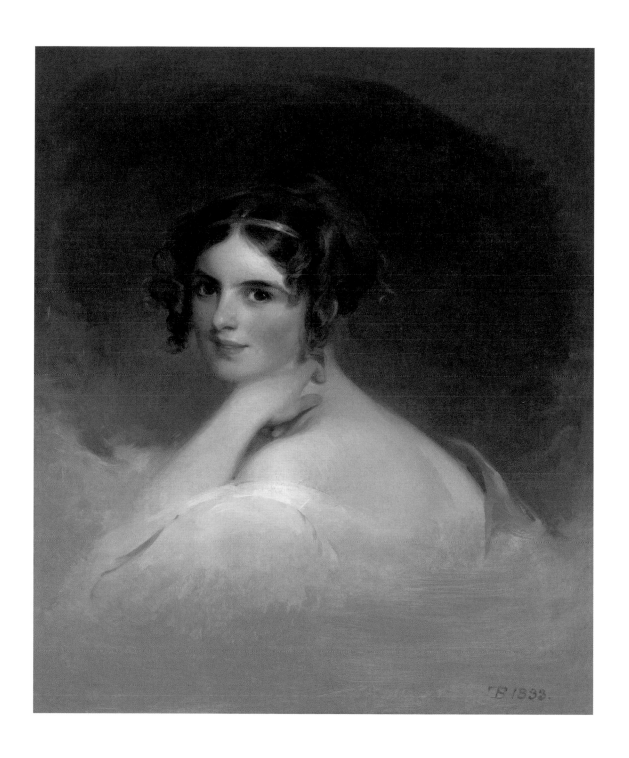

10 Thomas Sully (American, 1783–1872)
Frances Anne Kemble as Beatrice, 1833
Oil on canvas, 30 × 25 in.
Bequest of Henry C. Carey (The Carey Collection), 1879.8.24

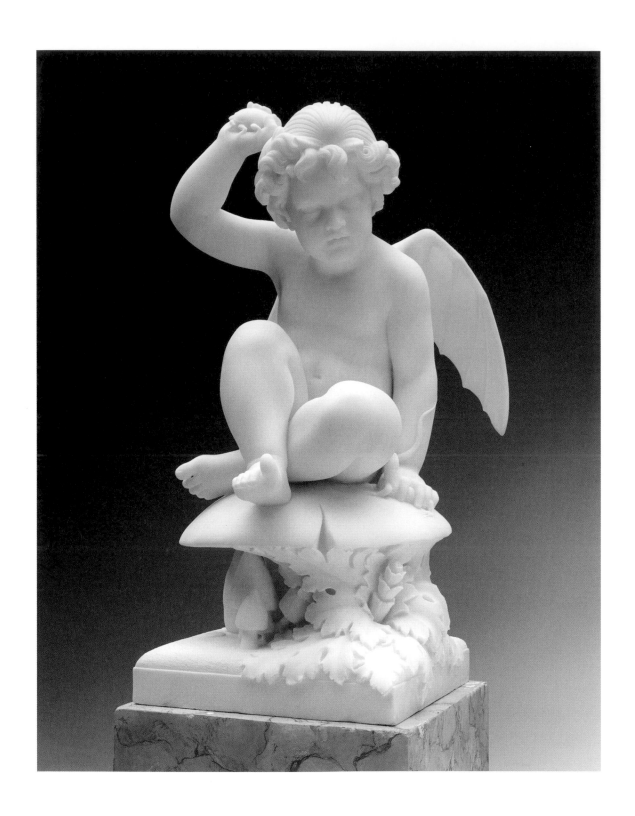

11 Harriet Hosmer (American, 1830–1908)
 Puck on a Toadstool, c. 1856
 Marble, 31¹⁄₁₆ × 18 × 18 in.
 Museum Purchase, 2016.1

12 Randolph Rogers (American, 1825–1892)
 Abraham Lincoln, c. 1866
 Marble, 27 × 21 × 13½ in.
 Gift of Richard D. Wood, 1866.1

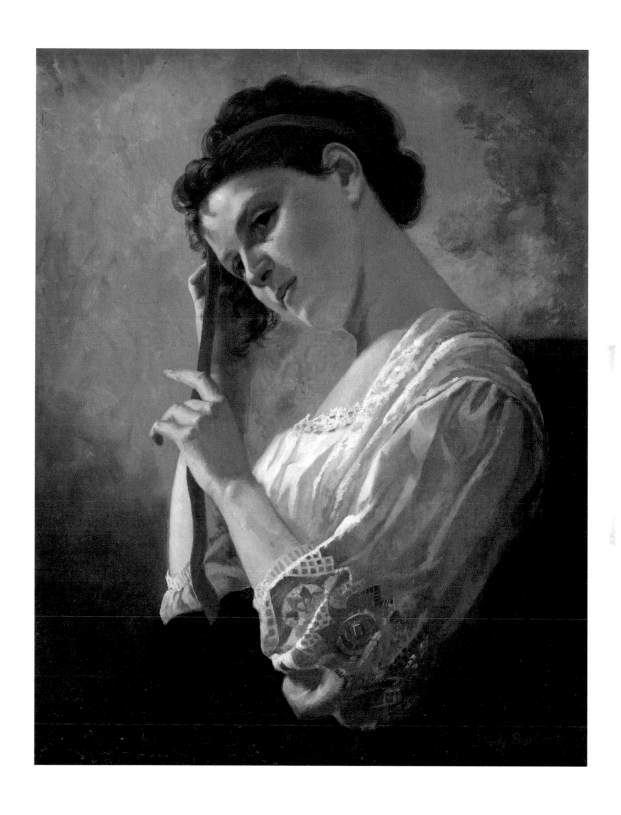

13 Emily Sartain (American, 1841–1927)
 Study, 1878
 Oil on canvas, 25 × 20 in.
 Museum Purchase, 2017.1

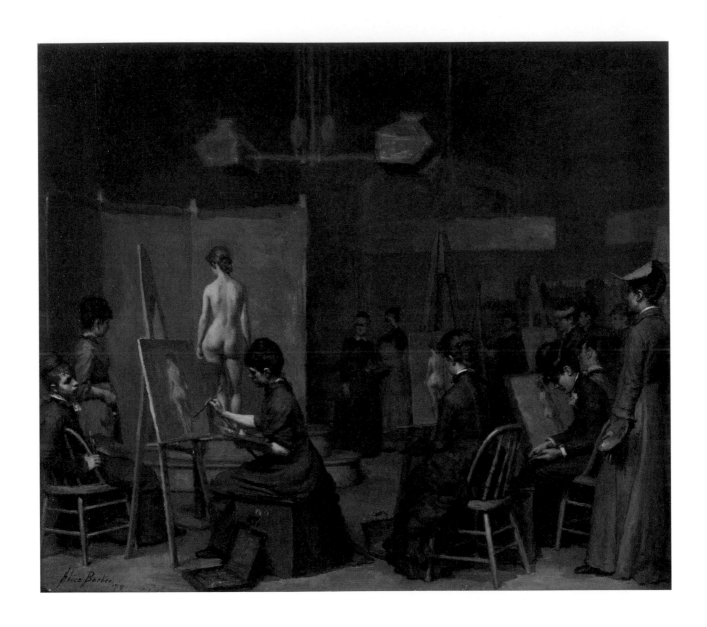

14 Alice Barber Stephens (American, 1858–1932)
 The Women's Life Class, c. 1879
 Oil on cardboard (grisaille), 12 × 14 in.
 Gift of the artist, 1879.2

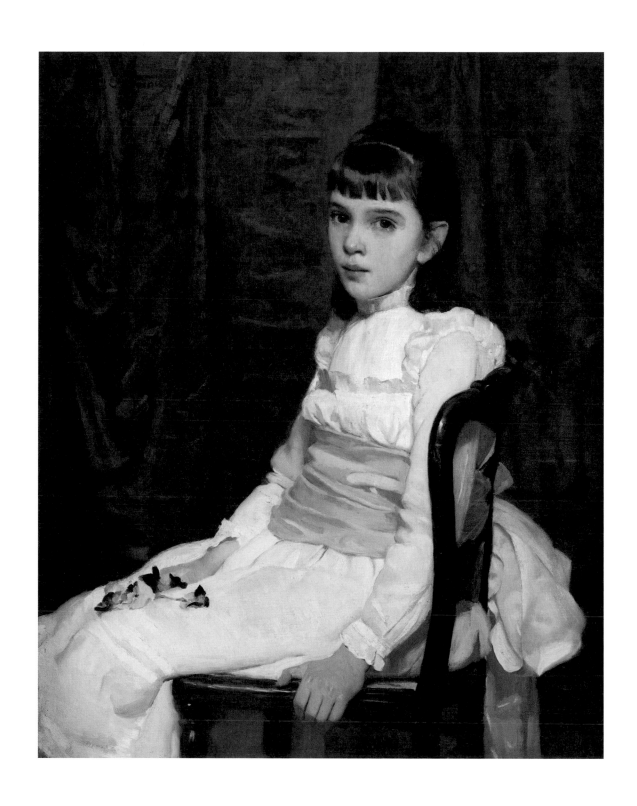

15 Cecilia Beaux (American, 1855–1942)
A Little Girl, 1887
Oil on canvas, 36 × 29 3/16 in.
Gift of Fanny Travis Cochran, 1955.12

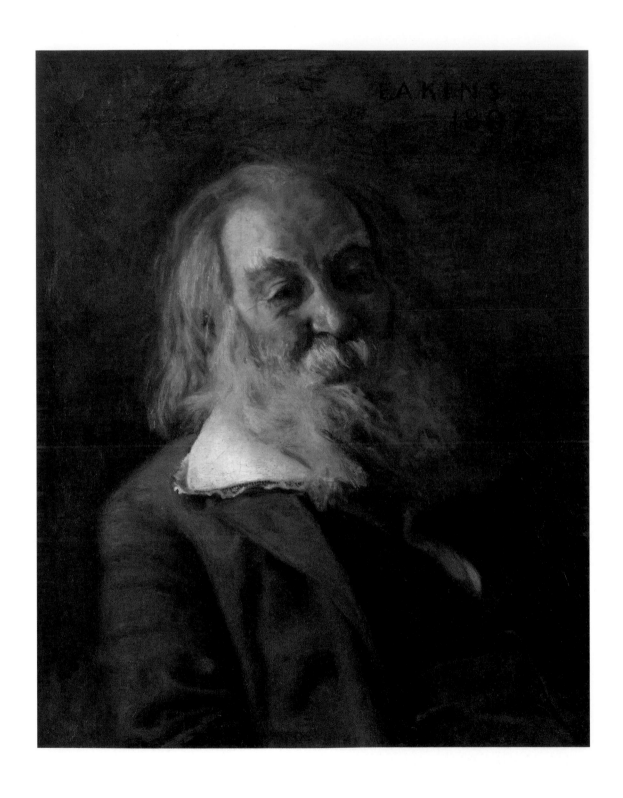

16 Thomas Eakins (American, 1844–1916)
 Walt Whitman, 1887–88
 Oil on canvas, 30⅛ × 24¼ in.
 General Fund, 1917.1

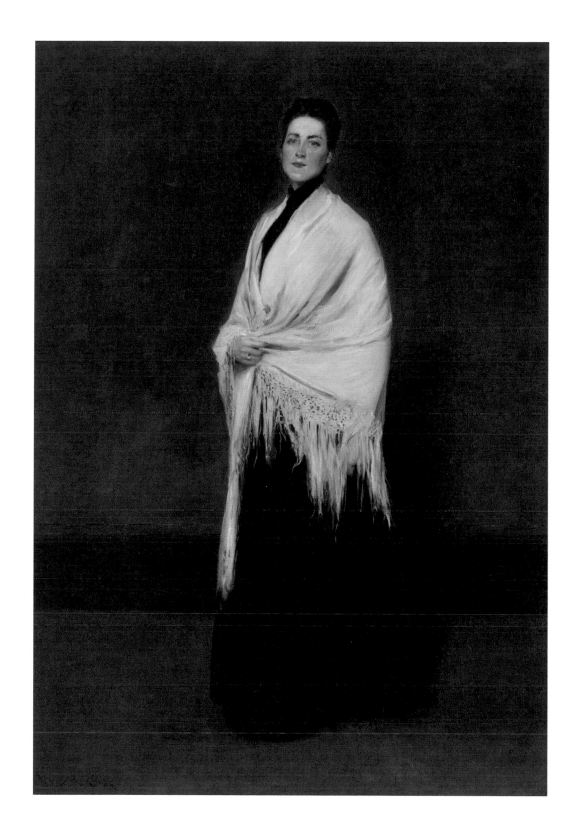

17 William Merritt Chase (American, 1849–1916)
 Portrait of Mrs. C. (Lady with a White Shawl), 1893
 Oil on canvas, 75 × 52 in.
 Joseph E. Temple Fund, 1895.1

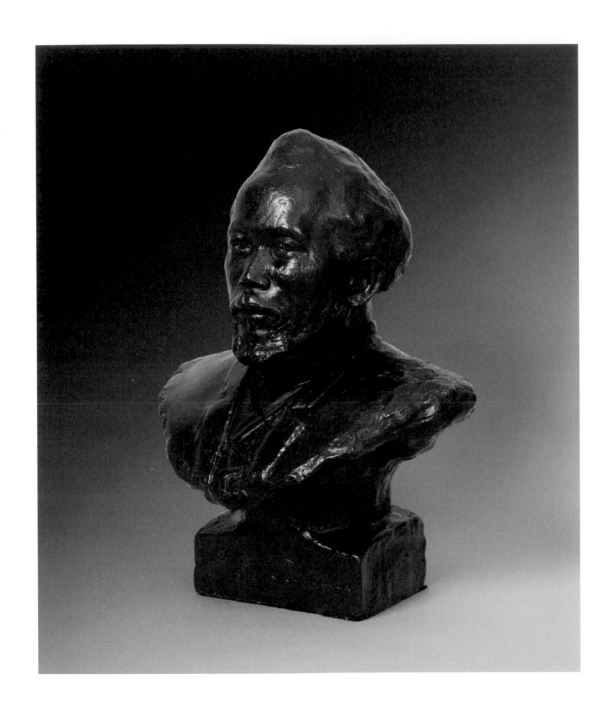

18 Henry Ossawa Tanner (American, 1859–1937)
 Benjamin Tucker Tanner, 1894 (cast 2013)
 Patinated bronze, 15 × 12½ × 9½ in.
 Gift of Leslie Tanner Moore and family, in honor of the Tanner family, 2014.30

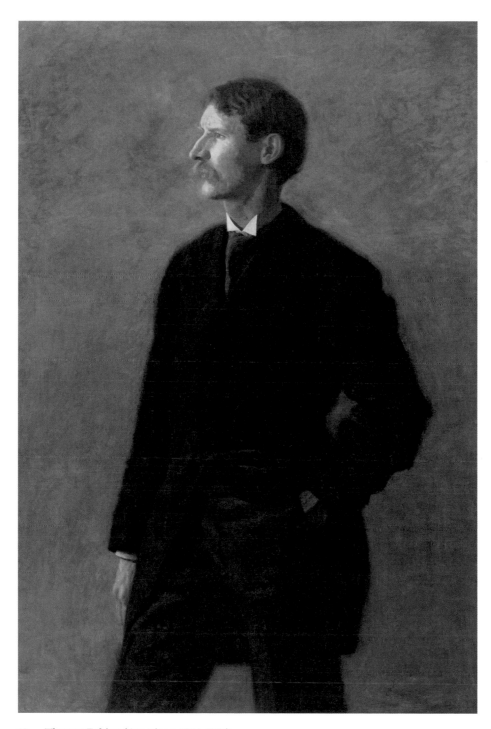

19 Thomas Eakins (American, 1844–1916)
Harrison S. Morris, 1896
Oil on canvas, 54½ × 36 in.
Partial gift of Harrison Morris Wright; partial purchase with funds provided by the Henry S. McNeil Fund, the Estate of John W. Merriam, the Samuel M. V. Hamilton Memorial Fund, the Women's Committee of the Pennsylvania Academy of the Fine Arts, Donald R. Caldwell, Jonathan L. Cohen, Dr. & Mrs. John A. Herring, William T. Justice & Mary Anne Dutt Justice, Charles E. Mather III & Mary MacGregor Mather, Robert W. Quinn, Herbert S. Riband, Jr. & Leah R. Riband, Mr. & Mrs. Joshua C. Thompson, & 36 anonymous subscribers, 2000.10

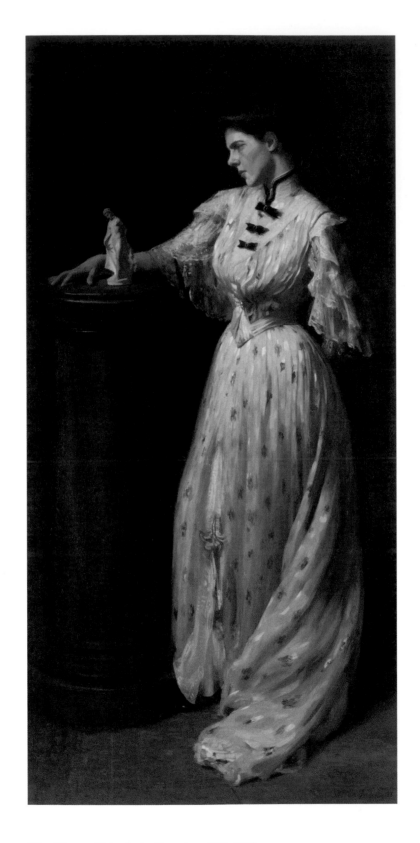

20 Thomas P. Anshutz (American, 1851–1912)
 The Tanagra, before 1909
 Oil on canvas, 80 × 40 in.
 Gift of the friends and admirers of the artist, 1912.1

21 Alice Kent Stoddard (American, 1883–1976)
 Elizabeth Sparhawk-Jones c. 1910
 Oil on canvas, 27 × 20¹⁄₁₆ in.
 Henry D. Gilpin Fund, 1911.4

22 Susan MacDowell Eakins (American, 1851–1938)
 Self-Portrait, 1910–20
 Oil on fabric, mounted on Masonite panel, 20 × 16 in.
 Charles Bregler's Thomas Eakins Collection, purchased with the partial support
 of the Pew Memorial Trust and the Henry C. Gibson Fund, 1985.68.39.2

23 Margaret Foster Richardson (American, 1881–c. 1945)
 A Motion Picture, 1912
 Oil on canvas, 40¾ × 23⅛ in.
 Henry D. Gilpin Fund, 1913.13

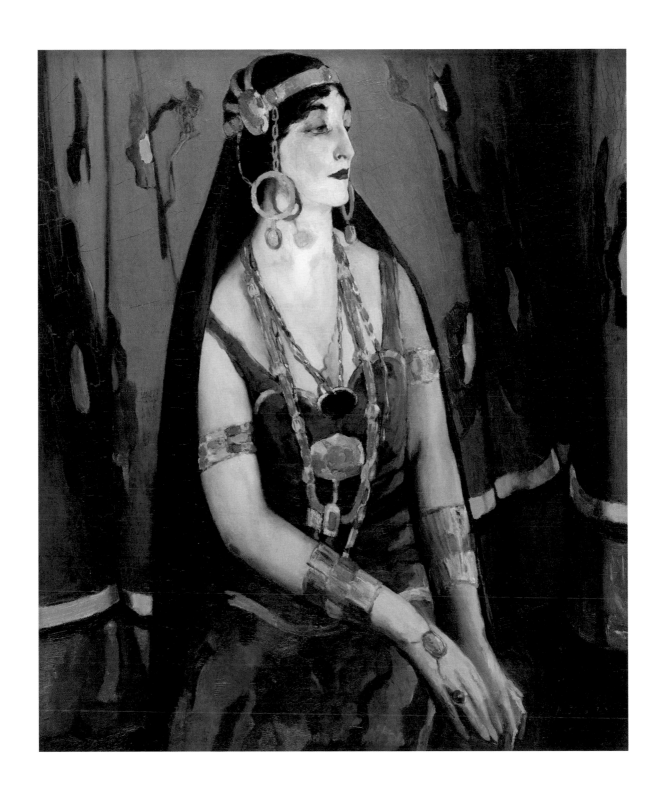

24　Arthur B. Carles (American, 1882–1952)
An Actress as Cleopatra, 1914
Oil on canvas, 30 ³⁄₁₆ × 25 ⅛ in.
John Lambert Fund, 1915.3

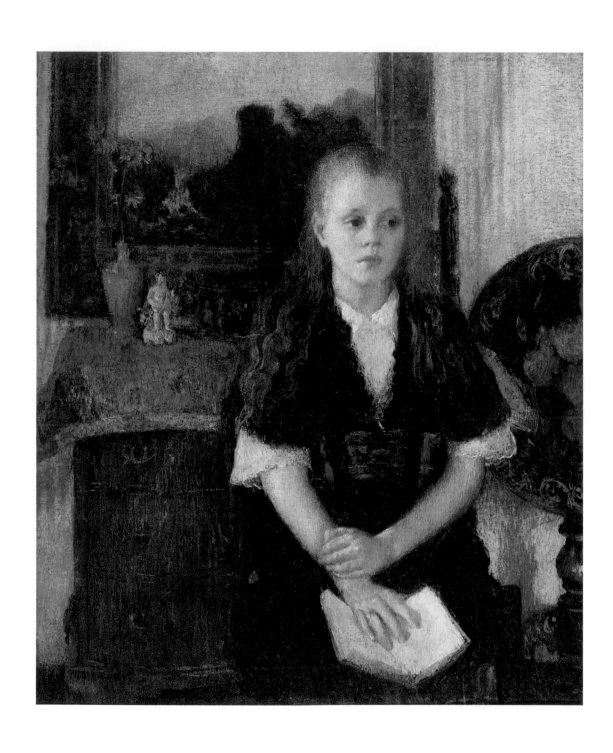

25 Lilian Westcott Hale (American, 1880–1963)
 When She Was a Little Girl, c. 1918
 Oil on canvas, 36 × 30 3/16 in.
 John Lambert Fund, 1919.3

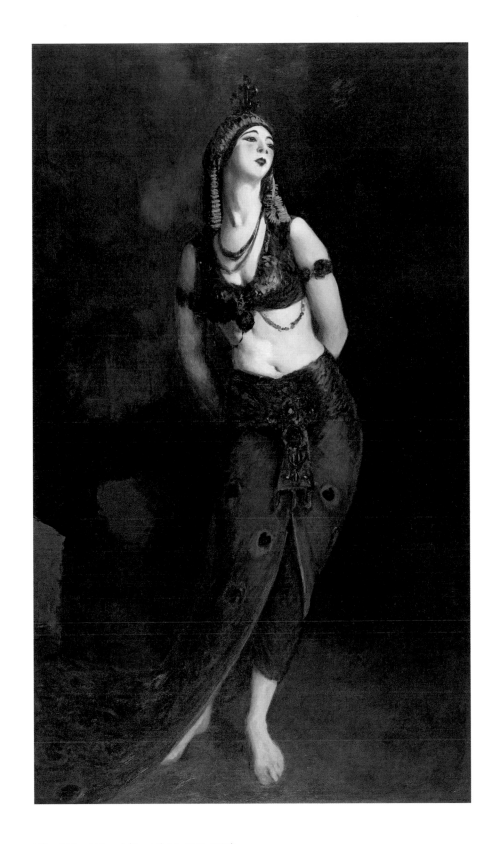

26 Robert Henri (American, 1865–1929)
Ruth St. Denis in the Peacock Dance, 1919
Oil on canvas, 85 × 49 in.
Gift of the Sameric Corporation in memory of Eric Shapiro, 1976.1

27　Isabel Bishop (American, 1902–1988)
Young Woman, 1937
Oil and egg tempera on Masonite panel, 30 × 21¼ in.
Henry D. Gilpin Fund, 1938.2

28 Dox Thrash (American, 1893–1965)
Self-Portrait, c. 1938
Oil on Masonite panel, 18 × 15¾ in.
Paris Haldeman Fund, 2008.24

29 Laura Wheeler Waring (American, 1887–1948)
The Study of a Student, c. 1940s
Oil on canvas board, 20 × 16 in.
Gift of Dr. Constance E. Clayton in loving memory of her mother Mrs. Williabell Clayton, 2019.3.69

30 Thomas Hart Benton (American, 1889–1975)
 Aaron, 1941
 Oil and egg tempera on canvas, mounted on plywood, 30 5/16 × 24 5/16 in.
 Joseph E. Temple Fund, 1943.3

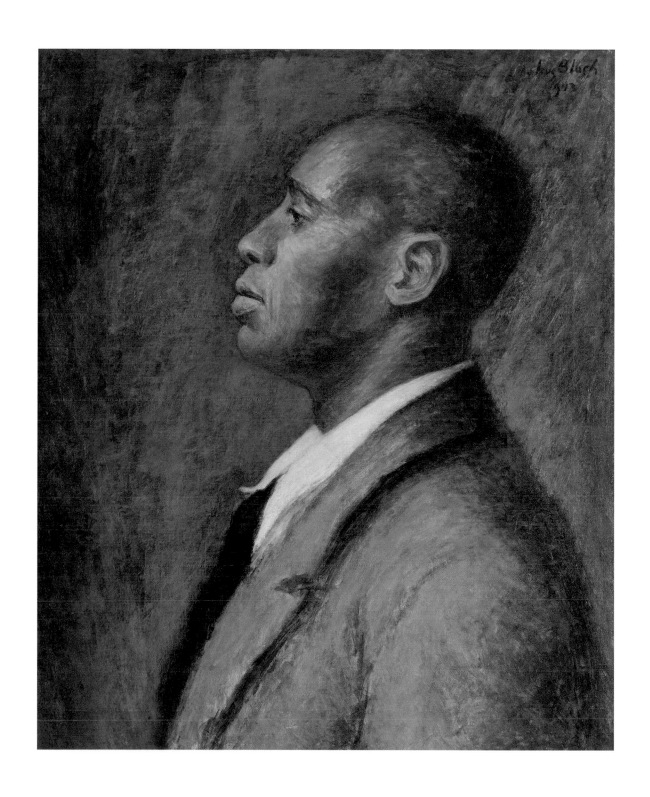

31 Julius T. Bloch (American, 1888–1966)
 Horace Pippin, 1943
 Oil on canvas, 24 × 20 1/16 in.
 Bequest of the artist in memory of Emma and Nathan Bloch, 1967.8.2

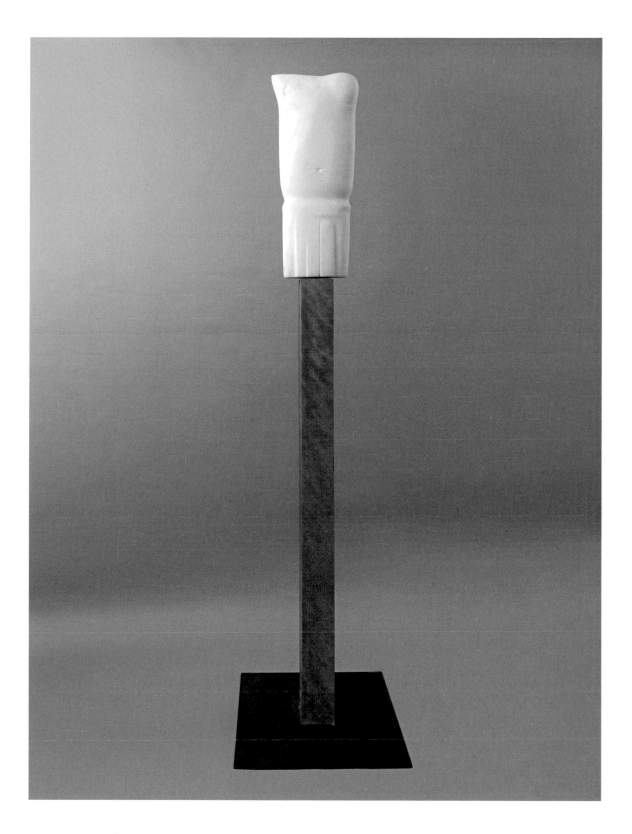

32 Isamu Noguchi (American, 1904–1988)
 Girl Torso, 1958
 Marble, 23 × 10 × 3 in.
 Henry D. Gilpin Fund, 1960.9

33 Elizabeth Osborne (American, b. 1936)
Woman with Red, 1962
Oil on canvas, 63⅛ × 46 in.
Gift of the Ford Foundation, 1964.1.6

34 Barkley L. Hendricks (American, 1945–2017)
 J. S. B. III, 1968
 Oil on canvas, 48 × 34⅜ in.
 Gift of Mr. and Mrs. Richardson Dilworth, 1969.17

35 James Brantley (American, b. 1945)
 Brother James, 1968
 Oil on canvas, 60⁷⁄₁₆ × 40¼ in.
 John Lambert Fund, 1970.1

HISTORY

36 Benjamin West (British American, 1738–1820)
 Penn's Treaty with the Indians, 1771–72
 Oil on canvas, 75½ × 107¾ in.
 Gift of Mrs. Sarah Harrison (The Joseph Harrison, Jr. Collection), 1878.1.10

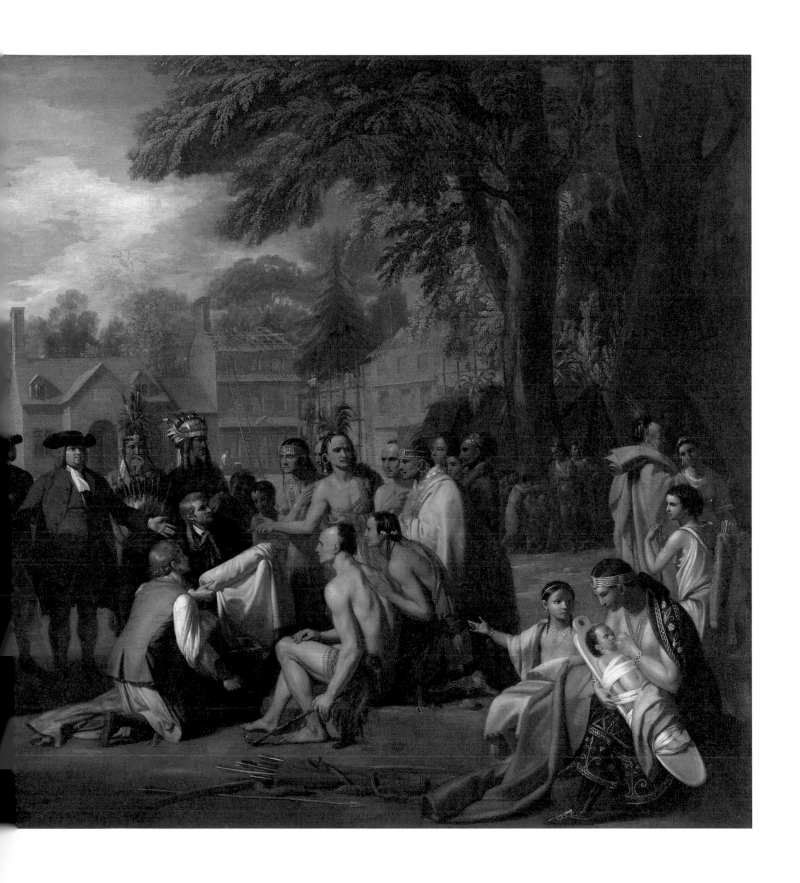

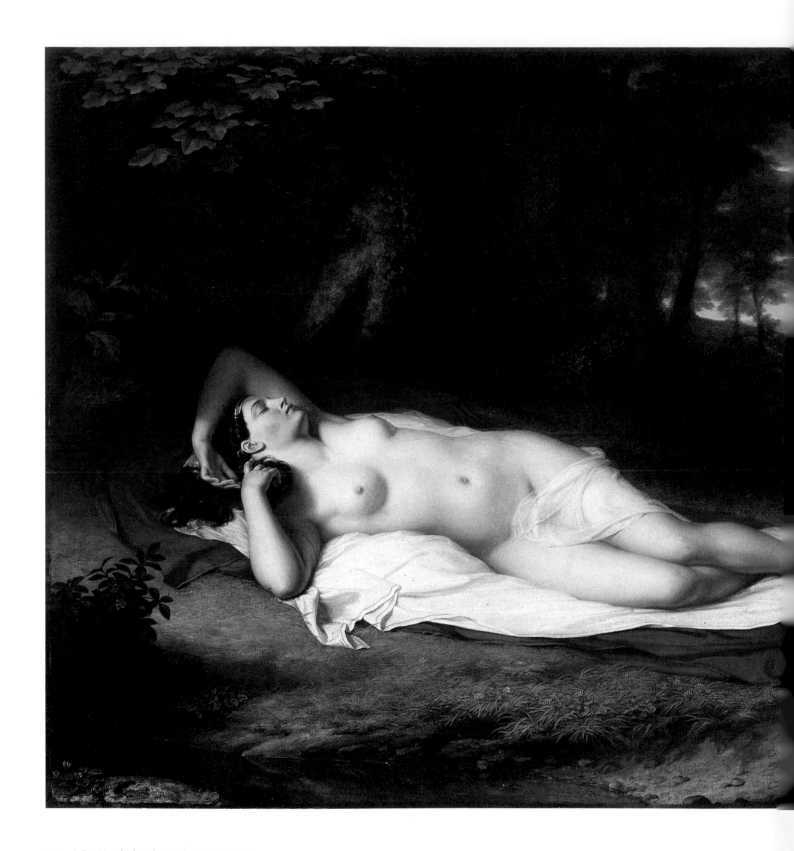

37 John Vanderlyn (American, 1775–1852)
Ariadne Asleep on the Island of Naxos, 1809–14
Oil on canvas, 68½ × 87 in.
Gift of Mrs. Sarah Harrison (The Joseph Harrison, Jr. Collection), 1878.1.11

38 William Rush (American, 1756–1833)
 Eagle, c. 1810
 Painted pine, 30⅜ × 32 × 12⅝ in.
 Gift of Wilson Mitchell, 1922.12.

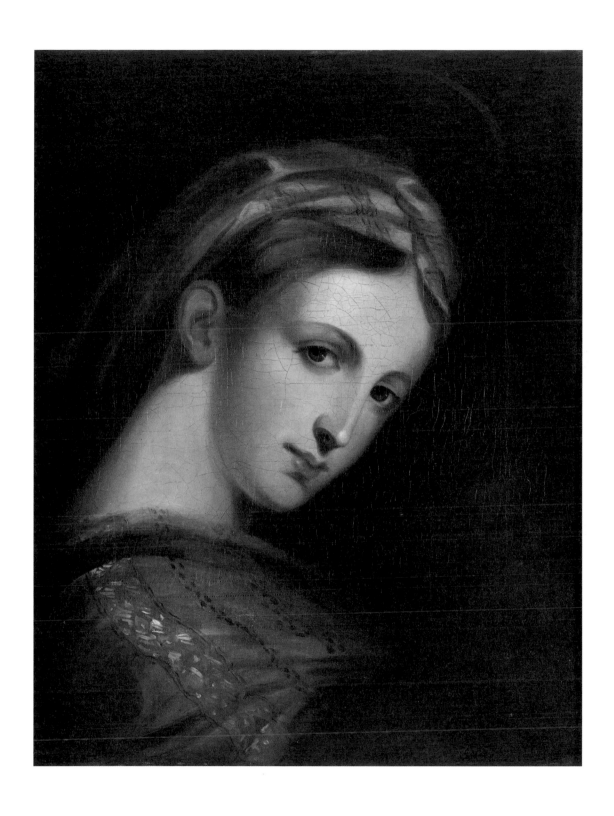

39 Jane Cooper Sully Darley (American, 1807–1877)
 Detail of the "Madonna della Sedia" (after Thomas Sully, after Raphael), 1826
 Oil on canvas, 19⅛ × 15⅛ in.
 Bequest of Harriet P. Smith, 1905.11.2

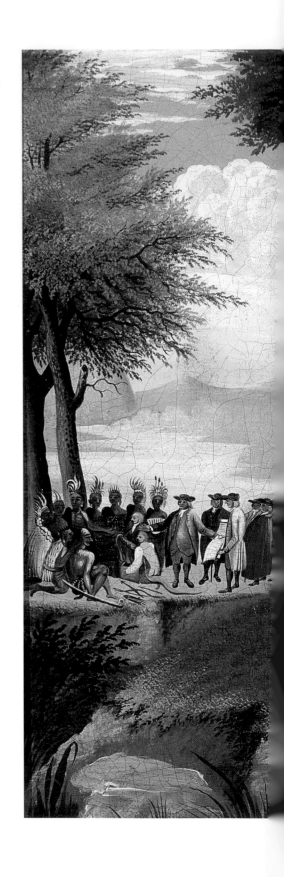

40 Edward Hicks (American, 1780–1849)
The Peaceable Kingdom, c. 1833
Oil on canvas, 17⅞ × 23¹⁵⁄₁₆ in.
John S. Phillips bequest, by exchange (acquired from the Philadelphia
Museum of Art, originally the 1950 bequest of Lisa Norris Elkins), 1985.17

41 Hiram Powers (American, 1805–1873)
 Proserpine, 1843
 Marble; carved about 1860, 25 × 19 × 10 in.
 Gift of John Livezey, 1864.5

42 Peter Frederick Rothermel (American, 1812–1895)
 De Soto Raising the Cross on the Banks of the Mississippi, 1851
 Oil on canvas, 40 × 50 in.
 Henry C. Gibson Fund and Mrs. Elliott R. Detchon, 1987.31

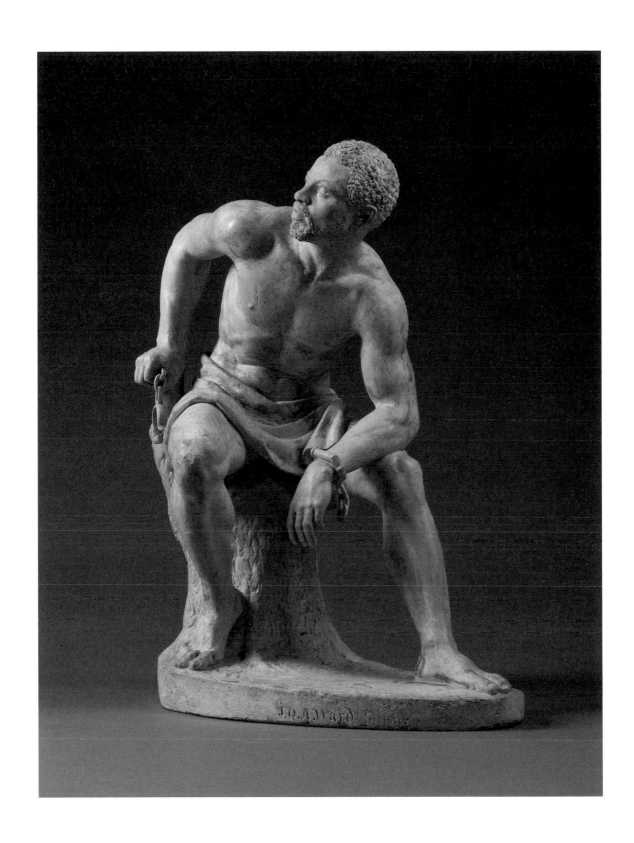

43 John Quincy Adams Ward (American, 1830–1910)
Freedman, 1863
Plaster, tinted yellow ochre, 20¼ × 15 × 7 in.
Gift of the artist, 1866.2

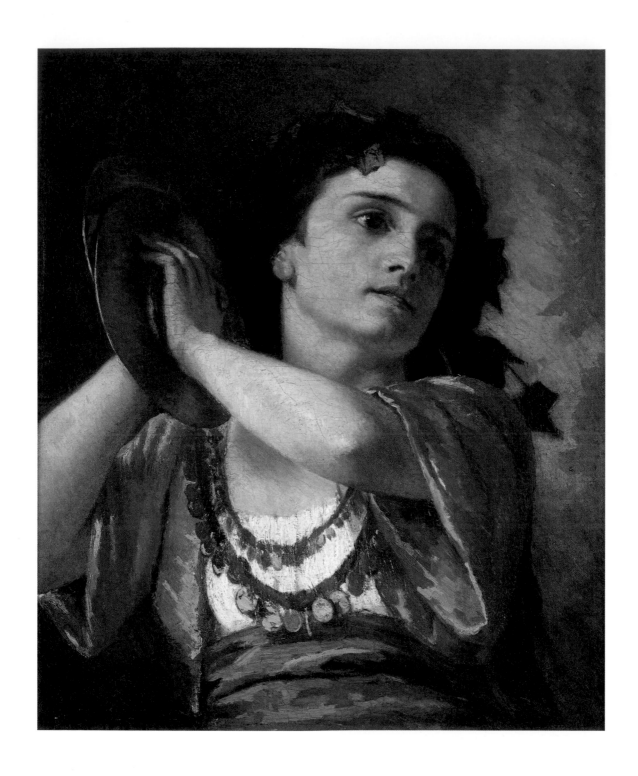

44 Mary Cassatt (American, 1844–1926)
Bacchante, 1872
Oil on canvas, 24 × 19 ¹⁵⁄₁₆ in.
Gift of John Frederick Lewis, 1932.13.1

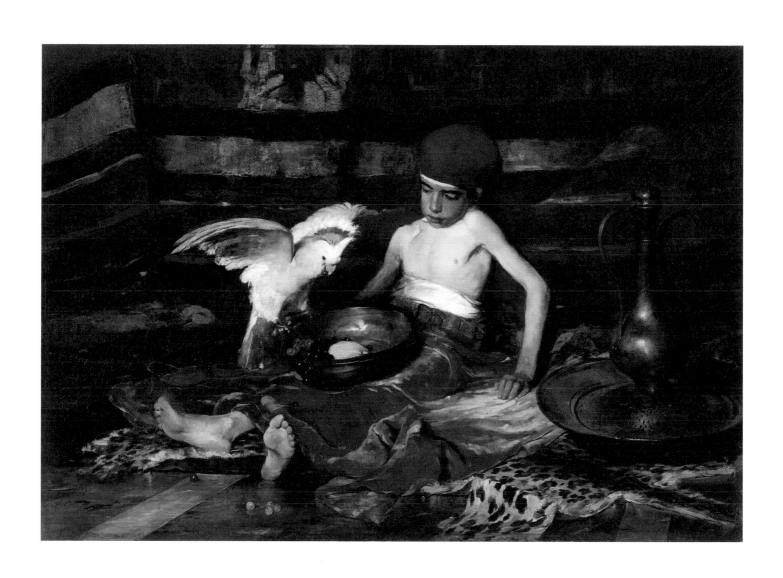

45 Frank Duveneck (American, 1848–1919)
 The Turkish Page, 1876
 Oil on canvas, 42 × 58¼ in.
 Joseph E. Temple Fund, 1894.1

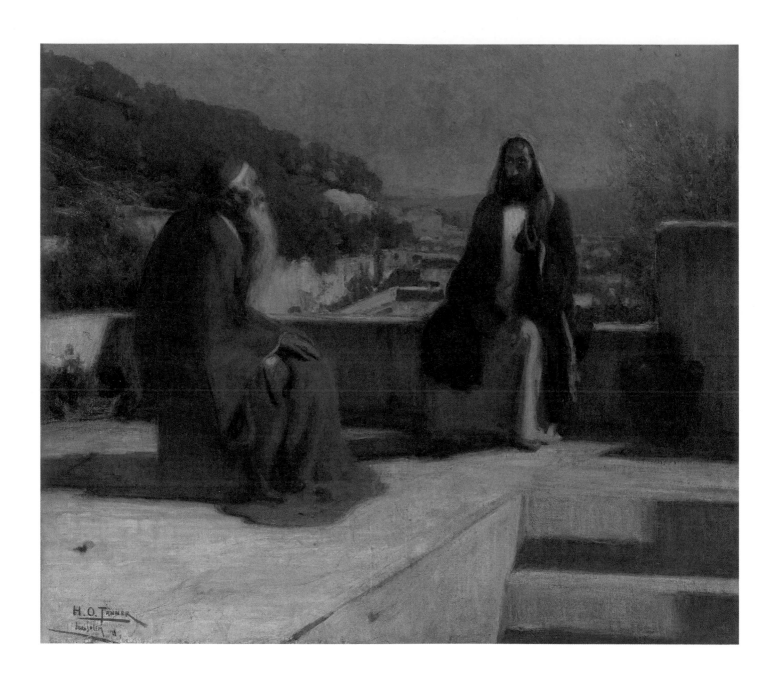

46 Henry Ossawa Tanner (American, 1859–1937)
 Nicodemus, 1899
 Oil on canvas, 33 11/16 × 39 1/2 in.
 Joseph E. Temple Fund, 1900.1

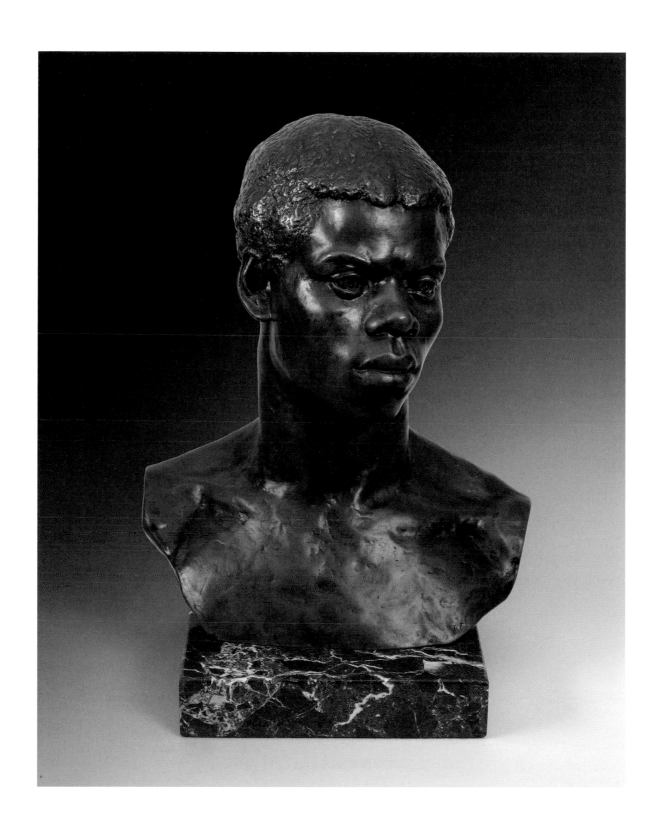

47 May Howard Jackson (American, 1877–1931)
Slave Boy, 1899 (cast 1988)
Bronze, 17 × 12 × 9 in.
Gift of Dr. Constance E. Clayton in loving memory of her mother Mrs. Williabell Clayton, 2019.3.66

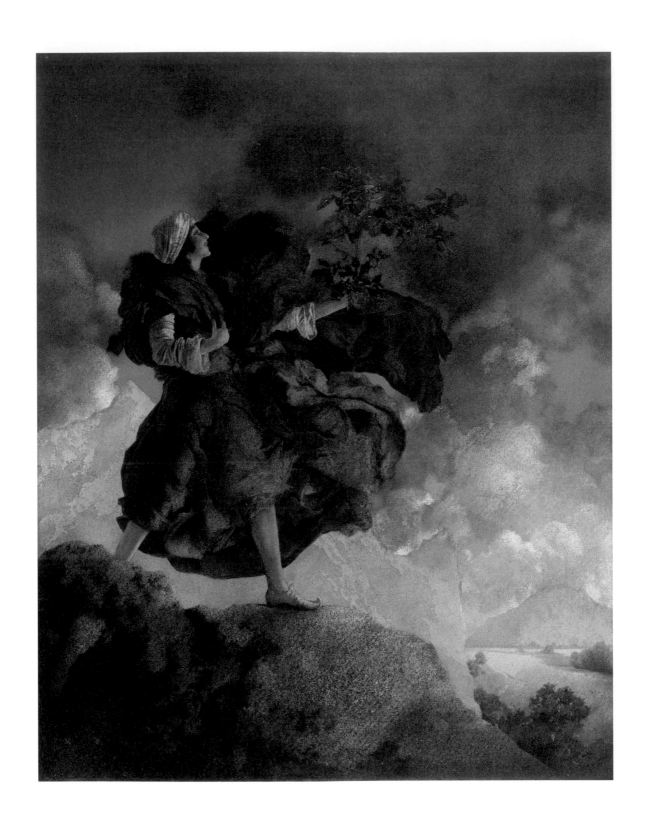

48 Maxfield Parrish (American, 1870–1966)
 Princess Parizade Bringing Home the Singing Tree, 1906
 Oil on paper, 20⅟₁₆ × 16⅟₁₆ in.
 Gift of Mrs. Francis P. Garvan, 1977.20

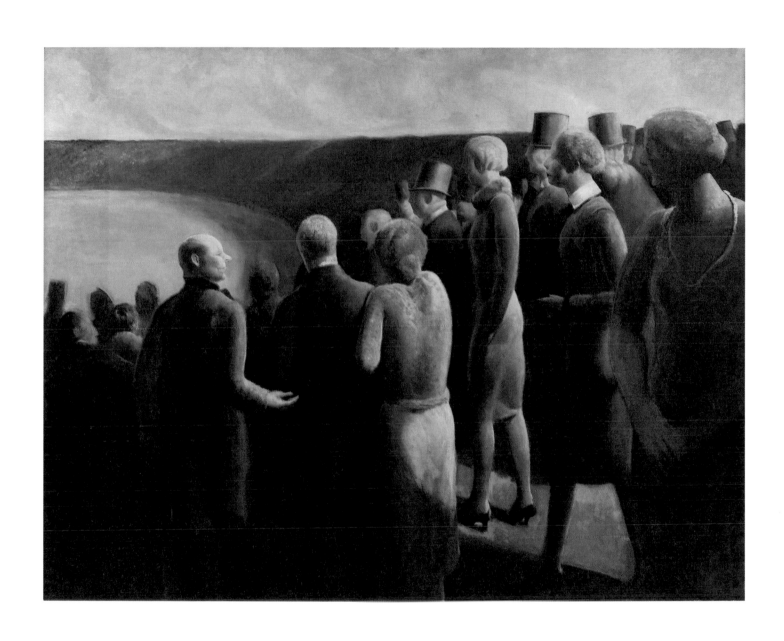

49 Guy Pène du Bois (American, 1884–1958)
 People, 1927
 Oil on canvas, 45⅛ × 57⅞ in.
 Joseph E. Temple Fund, 1943.12

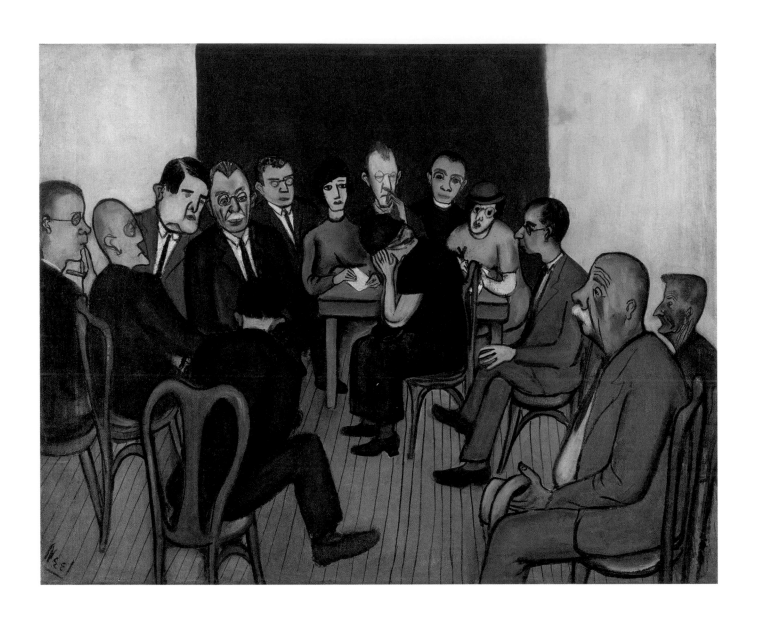

50 Alice Neel (American, 1900–1984)
 Investigation of Poverty at the Russell Sage Foundation, 1933
 Oil on canvas, 24⅛ × 30⅛ in.
 Art by Women Collection, Gift of Linda Lee Alter, 2010.27.2

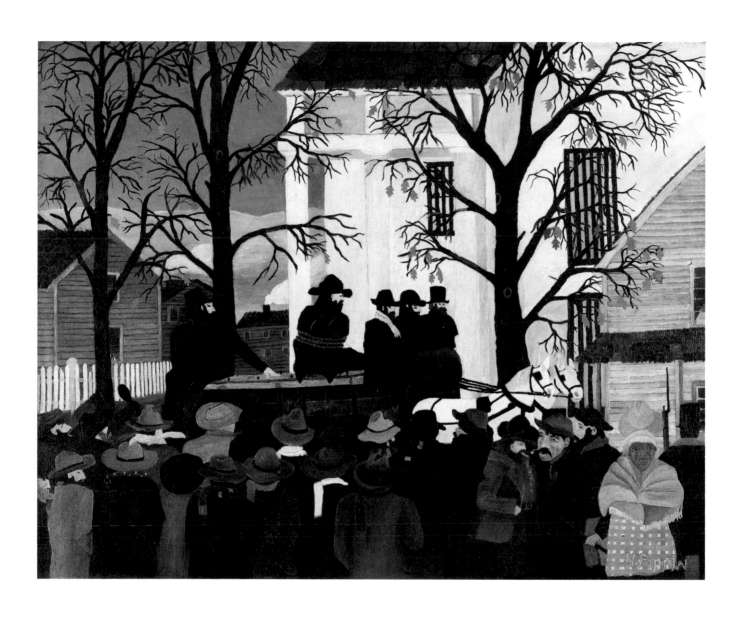

51 Horace Pippin (American, 1888–1946)
 John Brown Going to His Hanging, 1942
 Oil on canvas, 24⅛ × 30¼ in.
 John Lambert Fund, 1943.11

52 Janet Sobel (American, 1893–1968)
 Invasion Day, 1944
 Oil on canvas, 22 1/16 × 28 in.
 John Lambert Fund, 1945.11

53 Adolph Gottlieb (American, 1903–1974)
E, 1949
Oil on canvas, 48 × 36 in.
Henry C. Gibson Fund, 2005.2.

STILL LIFE

54 Raphaelle Peale (American, 1774–1825)
 Fox Grapes and Peaches, 1815
 Oil on wood, 9 11/16 × 11 7/16 in.
 Source unknown (probably Pennsylvania Academy purchase, 1817), 1845.6

55 Margaretta Angelica Peale (American, 1795–1882)
 Strawberries and Cherries, c. 1813–1830
 Oil on canvas, 10¹⁄₁₆ × 12⅛ in.
 Source unknown, 1924.11

56 Severin Roesen (American, 1815/16–1872 or after)
 Still Life with Fruit, c. 1855
 Oil on canvas, 30⅛ × 40⅛ in.
 Gift of William C. Williamson, by exchange, and Henry S. McNeil and the Henry D. Gilpin Fund, 1976.4

57 Mary Russell Smith (American, 1842–1878)
Picking Cherries, 1872
Oil on canvas, 20 1/16 × 23 3/16 in.
Gift of Russell Smith, 1878.3

58 William Michael Harnett (American, 1848–1892)
 Still Life, 1887
 Oil on canvas, 24¼ × 20 in.
 The Vivian O. and Meyer P. Potamkin Collection, Bequest of Vivian O. Potamkin, 2003.1.3

59 John F. Peto (American, 1854–1907)
Toms River Yacht Club, 1904
Oil on canvas, 20 × 16 in.
Purchased with funds from the Bequest of Henry C. Gibson, 1989.1

60 Marsden Hartley (American, 1877–1943)
Flower Abstraction, 1914
Oil on canvas, 42⅜ × 34⅞ in.
The Vivian O. and Meyer P. Potamkin Collection, Bequest of Vivian O. Potamkin, 2003.1.4

61 Georgia O'Keeffe (American, 1887–1986)
Red Canna, 1923
Oil on canvas, 12 × 9⅞ in.
The Vivian O. and Meyer P. Potamkin Collection, Bequest of Vivian O. Potamkin, 2003.1.8

62 Raymond Saunders (American, b. 1934)
La Chambre, 1961
Oil on canvas, 42¼ × 64¼ in.
John Lambert Fund, 1962.11

63 Louise Nevelson (American, 1899–1988)
 South Floral, 1972
 Painted wood construction, 95 × 32½ × 12 in.
 Art by Women Collection, Gift of Linda Lee Alter, 2010.27.3

GENRE PAINTING

64 John Lewis Krimmel (American, 1786–1821)
Fourth of July in Centre Square, before 1812
Oil on canvas, 22¾ × 29 in.
Pennsylvania Academy purchase (from the estate of Paul Beck, Jr.), 1845.3.1

65 William Sidney Mount (American, 1807–1868)
The Painter's Triumph, 1838
Oil on wood, 23⁹⁄₁₆ × 19½ in.
Bequest of Henry C. Carey (The Carey Collection), 1879.8.18

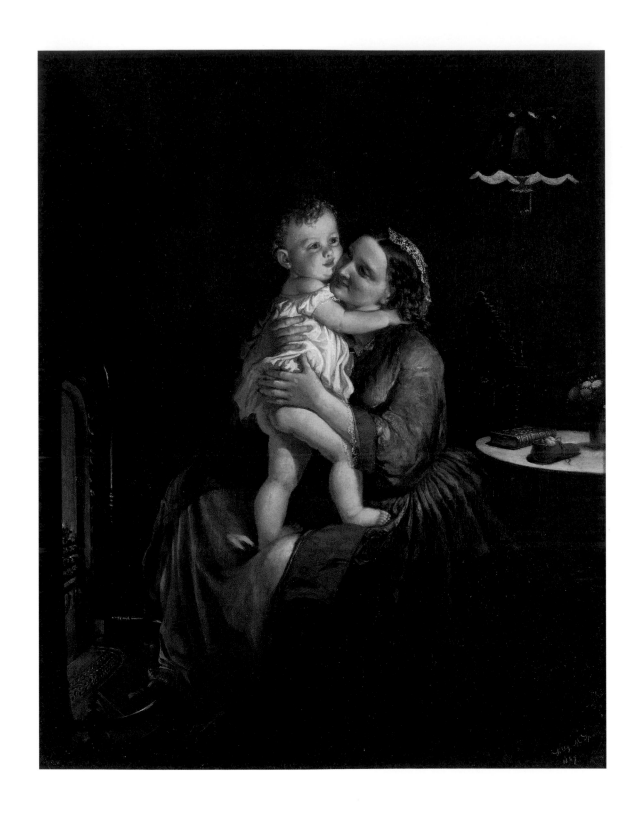

66 Lilly Martin Spencer (American, 1822–1902)
Mother and Child by the Hearth, 1867
Oil on canvas, 34½ × 27¼ in.
Edna Andrade, Wyckoff, and Harriet B. Kravitz Funds, 2010.2

67 Charles C. Curran (American, 1861–1942)
 A Breezy Day, 1887
 Oil on canvas, 11¹⁵⁄₁₆ × 20 in.
 Henry D. Gilpin Fund, 1899.1

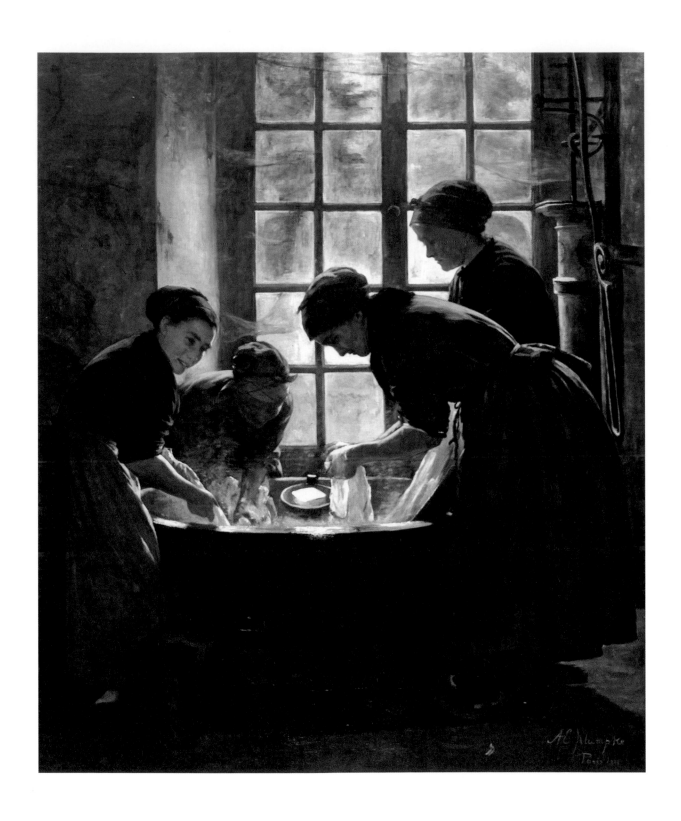

68 Anna Elizabeth Klumpke (American, 1856–1942)
In the Wash-House, 1888
Oil on canvas, mounted on wood, 79 × 67 in.
Gift of the artist, 1890.1

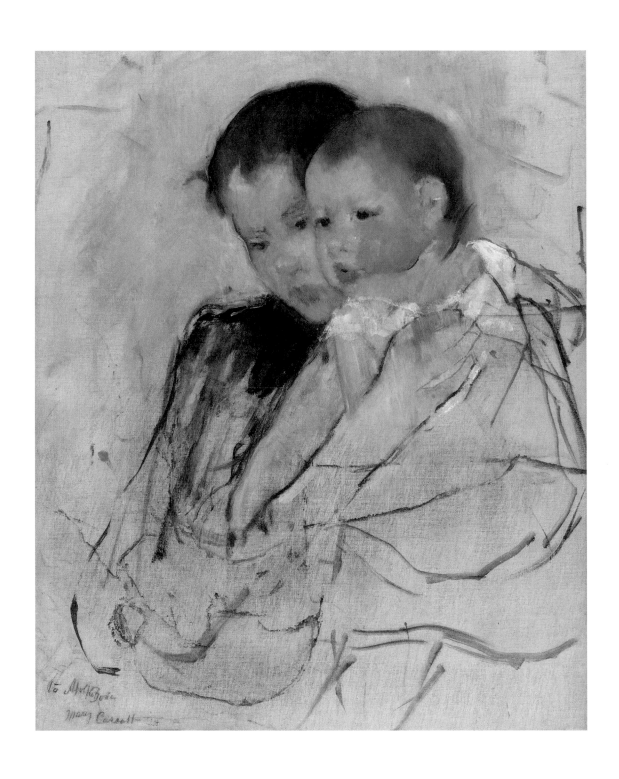

69 Mary Cassatt (American, 1844–1926)
Baby on Mother's Arm, c. 1891
Oil on canvas, 25 × 19¾ in.
Bequest of Peter Borie, 2003.15

70 Bessie Potter Vonnoh (American, 1872–1955)
Young Mother, 1896
Bronze with green and brown patina; lost-wax cast in 1913, 17 × 17 × 21 in.
Gift of Mrs. Edward H. Coates in memory of Edward H. Coates, 1923.9.8

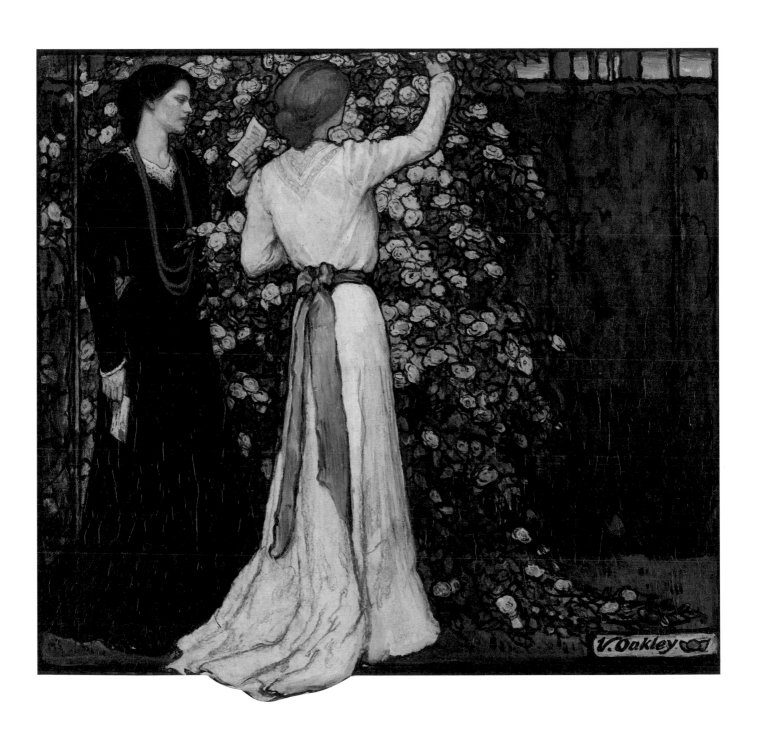

71 Violet Oakley (American, 1874–1961)
 June, c. 1902
 Oil, charcoal, and graphite on composition board, 16 3/16 × 17 1/16 in.
 Henry D. Gilpin Fund, 1903.4

72 Edmund C. Tarbell (American, 1862–1938)
 The Breakfast Room, c. 1903
 Oil on canvas, 25 × 30 in.
 Gift of Clement B. Newbold, 1973.25.3

73 Philip Leslie Hale (American, 1865–1931)
 The Crimson Rambler, c. 1908
 Oil on canvas, 25¼ × 30³⁄₁₆ in.
 Joseph E. Temple Fund, 1909.12

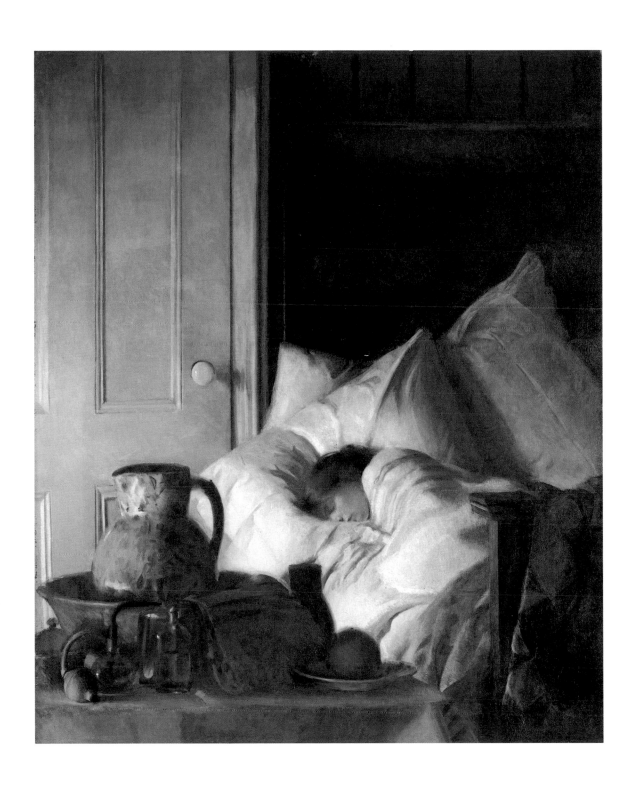

74 Elizabeth Okie Paxton (American, 1877–1971)
Sick a-Bed, 1916
Oil on canvas, 22 × 18 in.
Museum Purchase, 2017.11

75　Hilda Belcher (American, 1881–1963)
The Easter Window, c. 1920
Oil on canvas, 36 × 30 in.
John Lambert Fund, 1921.2

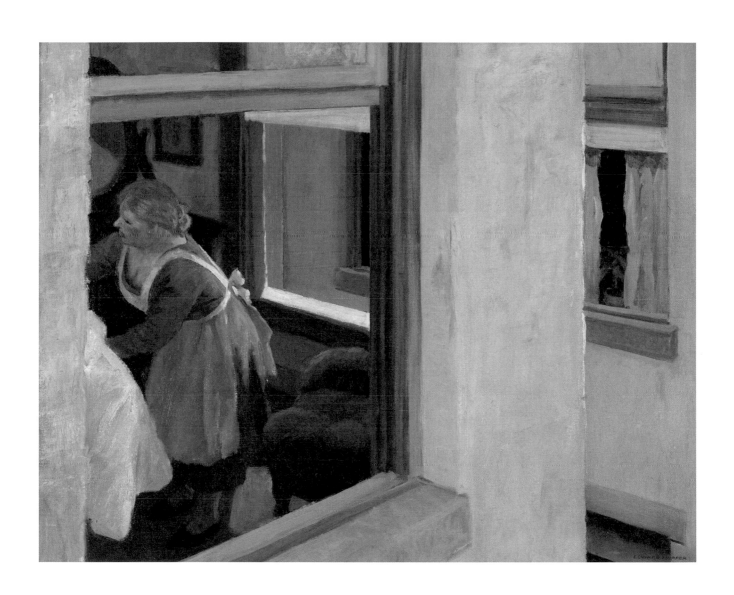

76 Edward Hopper (American, 1882–1967)
Apartment Houses, 1923
Oil on canvas, 24 × 28¹⁵⁄₁₆ in.
John Lambert Fund, 1925.5

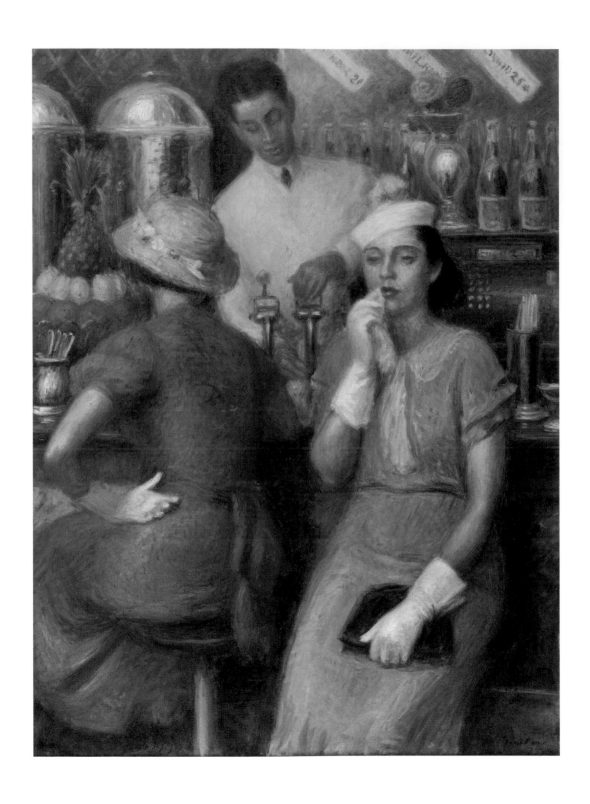

77 William J. Glackens (American, 1870–1938)
The Soda Fountain, 1935
Oil on canvas, 48 × 36 in.
Joseph E. Temple Fund and Henry D. Gilpin Fund, 1955.3

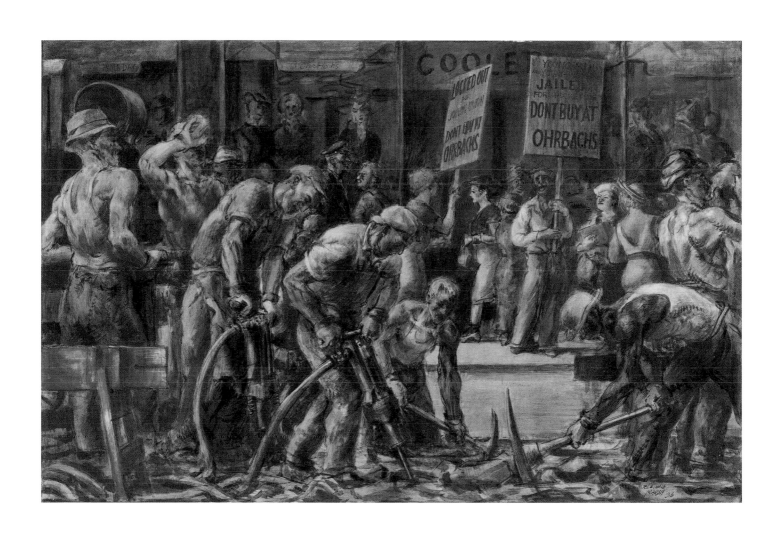

/8 Reginald Marsh (American, 1898–1954)
 End of 14th Street Crosstown Line, 1936
 Egg tempera on composition board, 24 × 36⅛ in.
 Henry D. Gilpin Fund, 1942.7

79 Edward L. Loper (American, 1916–2011)
 Sunday Afternoon, 1948
 Oil on canvas, 20 × 24 in.
 Gift of Dr. George J. Roth, 1970.34

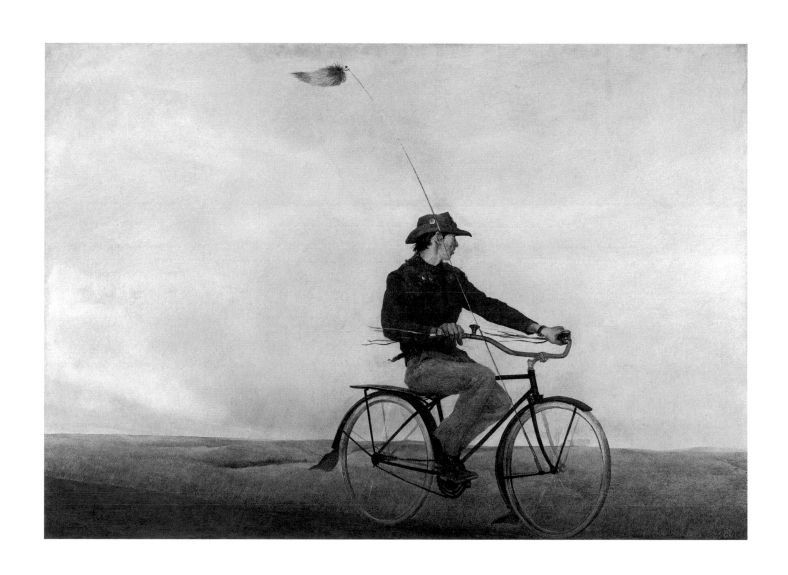

80 Andrew Wyeth (American, 1917–2009)
Young America, 1950
Egg tempera on gessoed board ("Renaissance Panel"), 32½ × 45⁵⁄₁₆ in.
Joseph E. Temple Fund, 1951.17

LANDSCAPE

81 Thomas Birch (American, 1779–1851)
 Fairmount Water Works, 1821
 Oil on canvas, 20⅛ × 30 1/16 in.
 Bequest of Charles Graff, 1845.1

82 Thomas Doughty (American, 1793–1856)
Landscape with Curving River, c. 1823
Oil on canvas, 18⁹⁄₁₆ × 27½ in.
Bequest of Henry C. Carey (The Carey Collection), 1879.8.5

83 David Johnson (American, 1827–1908)
The Hudson River from Fort Montgomery, 1870
Oil on canvas, 38½ × 60 in.
Museum Purchase, 2016.12

84 Thomas Moran (American, 1837–1926)
Two Women in the Woods, 1870
Oil on canvas, 20 × 30 in.
Orton P. Jackson Fund in memory of Emily Penrose Jackson, 2015.19

85 William Trost Richards (American, 1833–1905)
 February, 1887
 Oil on canvas, mounted on wood, 40¼ × 72 in.
 Gift of Mrs. Edward H. Coates
 (The Edward H. Coates Memorial Collection), 1923.9.5

86 Edward Bannister (Canadian, 1828–1901)
Newport, Rhode Island, 1890
Oil on canvas, 16⅛ × 26 in.
Museum Purchase, 2014.7

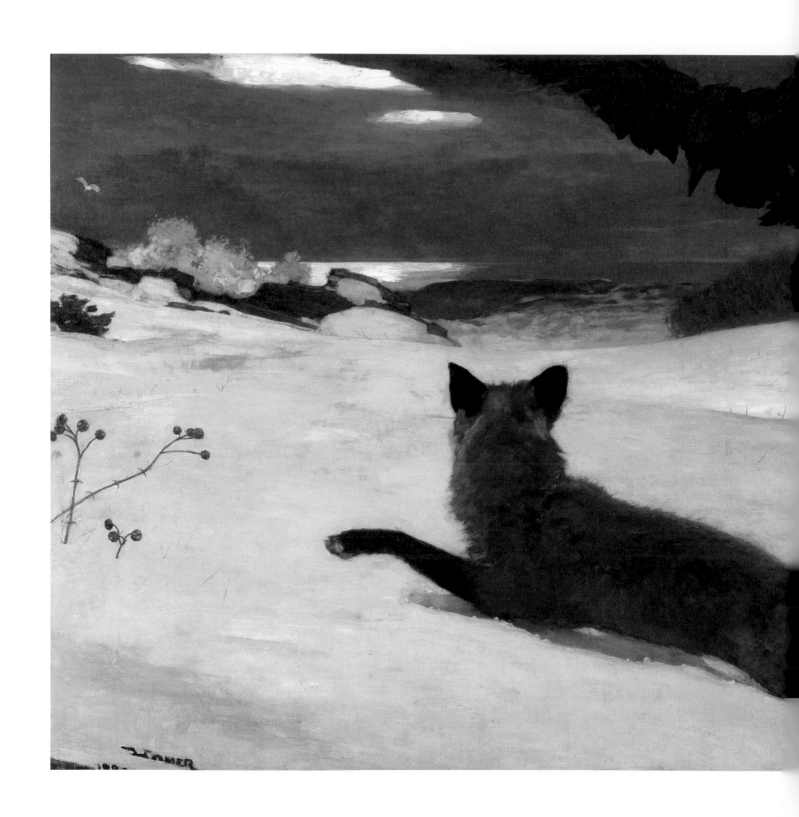

87 Winslow Homer (American, 1836–1910)
 Fox Hunt, 1893
 Oil on canvas, 38 × 68½ in.
 Joseph E. Temple Fund, 1894.4

88 John H. Twachtman (American, 1853–1902)
 Sailing in the Mist, 1890s
 Oil on canvas, 30 3/16 × 30 1/8 in.
 Joseph E. Temple Fund, 1906.1

89 Theodore Robinson (American, 1852–1896)
Port Ben, Delaware and Hudson Canal, 1893
Oil on canvas, 28¼ × 32¼ in.
Gift of the Society of American Artists as a memorial to Theodore Robinson, 1900.5

90 Childe Hassam (American, 1859–1935)
 The Hovel and the Skyscraper, 1904
 Oil on canvas, 34¾ × 31 in.
 The Vivian O. and Meyer P. Potamkin Collection, Bequest of Vivian O. Potamkin, 2003.1.5

91 George Bellows (American, 1882–1925)
North River, 1908
Oil on canvas, 32⅞ × 43 in.
Joseph E. Temple Fund, 1909.2

92 May Howard Jackson (American, 1877–1931)
 Morris Heights, N.Y. City, 1912
 Oil on linen canvas, mounted to wood panel, 12¼ × 16 in.
 Museum Purchase, 2018.14

93 Marianna Sloan (American, 1875–1954)
 A Rocky Beach, c. 1914
 Oil on canvas, 26³⁄₁₆ × 33³⁄₁₆ in.
 John Lambert Fund, 1915.6

94 Helen Fleck Seyffert (American, 1887–1947)
 Landscape, c. 1916
 Oil on canvas, 25 × 30 in.
 John Lambert Fund, 1917.7

95 Daniel Garber (American, 1880–1958)
 Quarry, 1917
 Oil on canvas, 50 × 60 in.
 Joseph E. Temple Fund, 1918.3

96 John Sloan (American, 1871–1951)
Jefferson Market, 1917, retouched 1922
Oil on canvas, 32 × 26⅛ in.
Henry D. Gilpin Fund, 1944.10

97 Arthur Garfield Dove (American, 1880–1946)
 Naples Yellow Morning, 1935
 Oil on linen, 25⅛ × 35 in.
 The Vivian O. and Meyer P. Potamkin Collection, Bequest of Vivian O. Potamkin, 2003.1.2

98 Charles Sheeler (American, 1883–1965)
 Clapboards, 1936
 Oil on canvas, 21⅛ × 19¼ in.
 Gift of W. Griffin Gribbel, R. Sturgis Ingersoll, John Frederick Lewis, Jr., William Clarke Mason, Henry T. McIlhenny,
 Lessing J. Rosenwald, Alfred G. B. Steel, Mrs. George F. Tyler, William L. Van Alen, and Joseph E. Widener, 1939.19

99 Milton Avery (American, 1885–1965)
Oxcart Blue Sea, 1943
Oil on canvas, 32⅛ × 44 in.
Gift of Mrs. Herbert Cameron Morris, 1952.16

100 George Copeland Ault (American, 1891–1948)
 Black Night: Russell's Corners, 1943
 Oil on canvas, 18 × 24¹⁄₁₆ in.
 John Lambert Fund, 1946.3

101 Stuart Davis (American, 1892–1964)
Ultra-Marine, 1943
Oil on canvas, 20 × 40⅛ in.
Joseph E. Temple Fund, 1952.11

102 Sonja Sekula (Swiss, 1918–1963)
The Rains, 1949
Oil and graphite on canvas, 46⅛ × 36 in.
Gift of the Betty Parsons Foundation, 1985.4

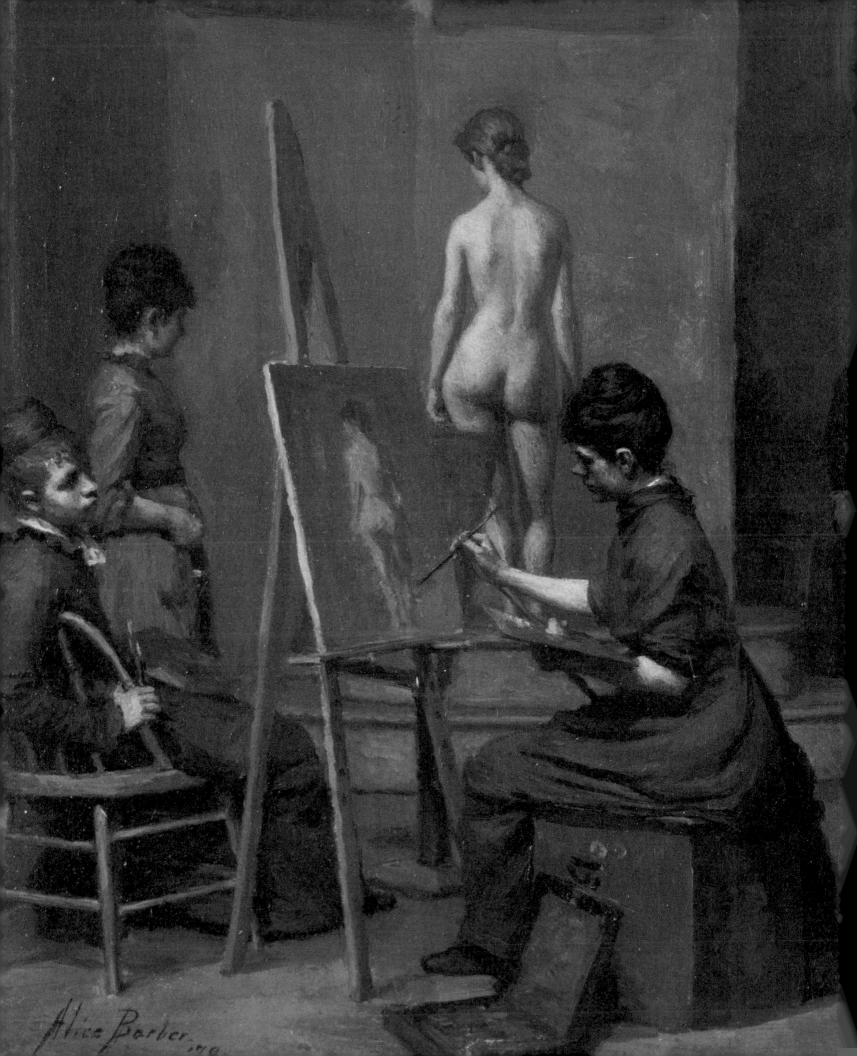

Alice Barber

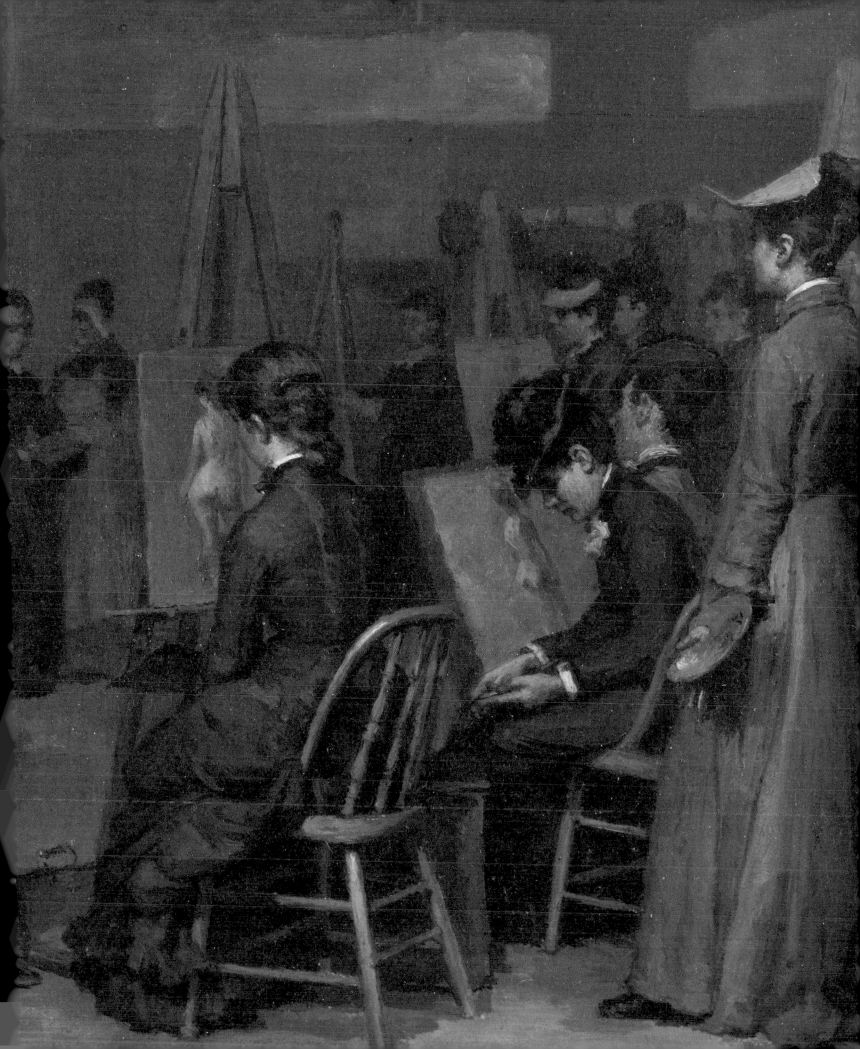

CURATORIAL ACKNOWLEDGMENTS

It has been a great pleasure for both of us to bring together the excellent curatorial and collection expertise of the Pennsylvania Academy of the Fine Arts and the adept exhibition planning of the American Federation of Arts to develop a show that includes some of the most important American paintings and sculptures from 1776 to 1976. These works, collected and exhibited by PAFA since the institution was founded, can now be shared with museums and their audiences who might otherwise not have access to them. Creating an exhibition involves a great deal of thought, planning, and execution and could not have happened without the full cooperation of the respective staff members from PAFA and the AFA.

The committed team at PAFA included Danielle McAdams, who arranged the logistics for the show, Adrian Cubillas, who photographed the collection for the catalogue, and Prior Reinhardt, who provided essential curatorial research support. Our gratitude to colleagues Jane Allsopp, Ellie Clark, Tina Disciollo-Acker, Karina Kacala, Megan McCarthy, Mary McGinn, Maryanne Murphy, Tatiana Perez, Eric Pryor, Josh Rickards, Jacob Stevens, Hoang Tran, Lori Waselchuk, Brittany Webb, and especially to the brilliant Monica Zimmerman, who always pushes curatorial interpretation to the highest, most engaged, level. Thank you to the William Penn Foundation, Richard C. von Hess, and Julie Jensen Bryan and Robert Bryan for making the exhibition possible at PAFA. Thank you to Amann and Estabrook Conservation and Tracy Gill of Gill & Lagodich for conservation and framing support. Thank you to PAFA Board members Emily Cavanagh, Anne E. McCollum, J. Brien Murphy, and Kenneth R. Woodcock for unfailing support of the exhibition. Thank you to intellectual co-conspirators Gwendolyn DuBois Shaw, Robert Cozzolino, Kathy Foster, David Lubin, Jodi Throckmorton, and Sylvia Yount for helping shape the exhibition checklist over the years.

At the AFA, we thank Pauline Forlenza and Andrew Eschelbacher, the driving forces behind the show. We were aided by Orian Neumann, Anne Reilly, Marta Torelli, and Katharine J. Wright, whose logistical expertise was invaluable and without whom the show would not be able to travel, and by Kristin N. Sarli, Lydia Albonesi, Sarah Fonseca, and Amanda Pajak who managed special events and communications surrounding the show. Special thanks are also due to Brian Keliher and Nicholas Cohn. We are grateful to Anna Barnet for all her work on this lavish catalogue.

The publication is rich in both scholarship and visual interest, and we are indebted to our contributors, Dana E. Byrd, Christian Ayne Crouch, and Jonathan D. Katz, who engaged with PAFA's collection to make a vital reassessment of American arts and PAFA's place in its history.

Finally, the exhibition could not be a success without our stellar venue partners: Wichita Art Museum, Kansas; the Albuquerque Museum of Art, New Mexico; the Philbrook Museum of Art, Oklahoma; and the Ackland Art Museum, The University of North Carolina at Chapel Hill. We are so thankful for all of our collaborators, and especially for the friendship we have formed on this special journey of scholarship and growth.

Anna O. Marley
Chief of Curatorial Affairs and
Kenneth R. Woodcock Curator
of Historical American Art
Pennsylvania Academy of the Fine Arts

Michèle Wije
Former Curator
American Federation of Arts

CONTRIBUTORS

Dana E. Byrd is Associate Professor of Art History at Bowdoin College.

Christian Ayne Crouch is Dean of Graduate Studies and Associate Professor of Historical Studies and American and Indigenous Studies at Bard College.

Jonathan D. Katz is Professor of Practice, History of Art and Gender, Sexuality, and Women's Studies at the University of Pennsylvania.

Anna O. Marley is Chief of Curatorial Affairs and Kenneth R. Woodcock Curator of Historical American Art at the Pennsylvania Academy of the Fine Arts.

Michèle Wije is Curatorial Project Manager at the Yale University Art Gallery and former Curator at the American Federation of Fine Arts.

INDEX

PHOTOGRAPHY CREDITS

All works are courtesy of the Pennsylvania Academy of the Fine Arts and were photographed by Adrian Cubillas and Barbara Katus unless otherwise noted.

DETAILS

Front cover Barkley L. Hendricks, *J. S. B. III*, 1968 (pl. 34)

Back cover Detail from Charles Willson Peale, *The Artist in His Museum*, 1822 (pl. 8)

2 Detail from Laura Wheeler Waring, *The Study of a Student*, c. 1940s (pl. 29)

4 Detail from Violet Oakley, *June*, c. 1902 (pl. 71)

82–83 Detail from Arthur B. Carles, *An Actress as Cleopatra*, 1914 (pl. 24)

124–25 Detail from Alice Neel, *Investigation of Poverty at the Russell Sage Foundation*, 1933 (pl. 50)

150–51 Detail from William Michael Harnett, *Still Life*, 1887 (pl. 58)

164–65 Detail from Charles C. Curran, *A Breezy Day*, 1887 (pl. 67)

184–85 Detail from Marianna Sloan, *A Rocky Beach*, c. 1914 (pl. 93)

214–15 Detail from Alice Barber Stephens, *The Women's Life Class*, c. 1879 (pl. 14)

Front cover, 121 © Barkley L. Hendricks. Courtesy of the Estate of Barkley L. Hendricks and Jack Shainman Gallery, New York

12 Courtesy of the artist and Garth Greenan Gallery, New York

20 (detail), 123 © James Brantley

33 (right) Used by permission of the Folger Shakespeare Library

41 The Art Institute of Chicago / Art Resource, NY

42 © Meta Vaux Warrick Fuller

44 Courtesy of the Moorland-Spingarn Research Center, Howard University Archives, Howard University, Washington DC

47, 213 © Sonja Sekula Estate

62, 115 © 2023 T.H. and R.P. Benton Trusts / Licensed by Artists Rights Society (ARS), New York

78 Image copyright © The Metropolitan Museum of Art. Image source: Art Resource, NY

80 © 2023 Georgia O'Keeffe Museum / Artists Rights Society (ARS), New York; Digital image © Whitney Museum of American Art / Licensed by Scala/ Art Resource, NY

112 © Estate of Isabel Bishop. Courtesy of DC Moore Gallery, New York

119 © 2023 The Isamu Noguchi Foundation and Garden Museum, New York / Artists Rights Society (ARS), New York

120 Courtesy of the artist

124–25 (detail), 144 © The Estate of Alice Neel. Courtesy The Estate of Alice Neel and David Zwirner

142 © 2023 Maxfield Parrish Family, LLC / Licensed by VAGA at Artists Rights Society (ARS), NY

143 Guy Pène du Bois. Courtesy of the Estate of Yvonne Pène du Bois McKenney and 511 Gallery LLC

146–47 © Estate of Janet Sobel. Courtesy Gary Snyder Fine Art

149 © 2023 Adolph and Esther Gottlieb Foundation / Licensed by VAGA at Artists Rights Society (ARS), NY

159 © 2023 Georgia O'Keeffe Museum / Artists Rights Society (ARS), New York

160–61 Courtesy of the artist and Andrew Kreps Gallery

163 © 2023 Estate of Louise Nevelson / Artists Rights Society (ARS), New York

177 © Elizabeth Okie Paxton

178 Estate of the artist, courtesy of Martha Richardson Fine Art, Boston

179 © 2023 Heirs of Josephine N. Hopper / Licensed by Artists Rights Society (ARS), NY

181 © 2023 Estate of Reginald Marsh / Art Students League, New York / Artists Rights Society (ARS), New York

182 Edward Loper Sr.

183 © 2023 Andrew Wyeth / Artists Rights Society (ARS), New York

208 © 2023 The Milton Avery Trust / Artists Rights Society (ARS), New York

210–11 © 2023 Estate of Stuart Davis / Licensed by VAGA at Artists Rights Society (ARS), NY

AMERICAN FEDERATION OF ARTS TRUSTEES AND BENEFACTORS

This catalogue is published on
the occasion of the exhibition

MAKING AMERICAN ARTISTS:
STORIES FROM THE PENNSYLVANIA
ACADEMY OF THE FINE ARTS,
1776–1976

co-organized by the American Federation
of Arts and the Pennsylvania Academy of
the Fine Arts.

This exhibition is curated by Anna O. Marley,
Chief of Curatorial Affairs and Kenneth
R. Woodcock Curator of Historical American
Art, Pennsylvania Academy of the Fine Arts.

EXHIBITION ITINERARY

Wichita Art Museum,
Kansas
January 28–April 21, 2024

Albuquerque Museum of Art,
New Mexico
May 18–August 11, 2024

Philbrook Museum of Art,
Tulsa, Oklahoma
September 21, 2024–January 5, 2025

Ackland Art Museum,
The University of North Carolina
at Chapel Hill
February 5–May 11, 2025

Published in 2023 by
American Federation of Arts
305 East 47th Street, 10th Floor
New York, NY 10017
www.amfedarts.org

Hirmer Publishers
Bayerstrasse 57-59
80335 Munich
Germany
www.hirmerpublishers.com

© 2023 American Federation of Arts

Library of Congress Control Number:
2023930566
ISBN 978-3-7774-4098-9

FOR THE AMERICAN FEDERATION OF ARTS

Manager of Publications:
Anna Barnet

Project Curators:
Associate Curator Katharine J. Wright
and former Curator Michèle Wije

Curatorial Coordinator:
Marta Torelli

Intern:
Kit Moszynski

Image Permissions Specialist:
Anne Levine

FOR HIRMER PUBLISHERS

Senior Editor Hirmer Publishers:
Elisabeth Rochau-Shalem

Project Manager Hirmer Publishers:
Rainer Arnold

Design and visual editing:
Sabine Frohmader

Copyediting and proofreading:
David Sánchez Cano

Pre-press:
Reproline Mediateam, Unterföhring

Printing & binding:
Printer Trento s.r.l.

Printed in Italy

Paper:
Garda Ultramatt 150 g/m^2

Typefaces:
Bennet Text (Lipton Letter Design),
Continuo (Delve Fonts),
Proxima Nova (Mark Simonson Studio)

The American Federation of Arts is the leader
in traveling exhibitions internationally.
A nonprofit institution founded in 1909, the
AFA is dedicated to enriching the public's
experience and understanding of the visual
arts through organizing and touring art
exhibitions for presentation in museums
around the world, publishing scholarly
exhibition catalogues, developing innovative
educational programs, and fostering a better
understanding among nations through the
international exchange of art.

Founded in 1805, the Pennsylvania Academy
of the Fine Arts has provided leadership in
the arts and support for artists for over
200 years. PAFA is committed to expanding
the conversation around what it means to
be an American artist and through its
exhibitions and programs strives to reflect
the diversity of the American story. PAFA
seeks to be an inclusive space for ongoing
artistic conversations, where voices from
every background are heard, and artists at
every age and stage of development gather to
create, explore, learn, and form a community.

MIX
Paper | Supporting
responsible forestry
FSC® C015829
www.fsc.org